IMAGES
of America

PALOMAR
MOUNTAIN

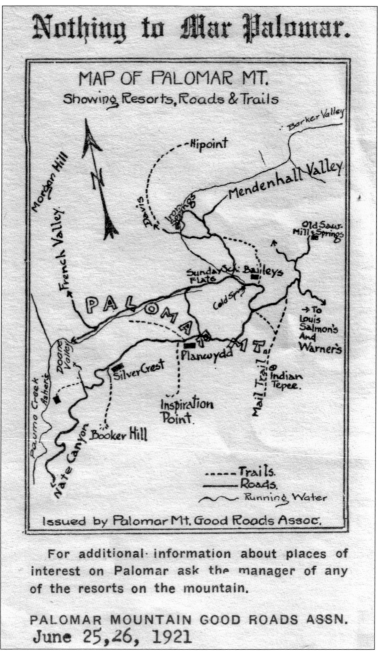

Nothing to Mar Palomar.

MAP OF PALOMAR MT.
Showing Resorts, Roads & Trails

Barker Valley

Hipoint

Morgan Hill

French Valley

Davis

Mendenhall Valley

Old Saw. Mill Springs

P A L O M A R M T.

Sunday Sch. Baileys
FLATS

Cold Spr.

→ To Louis Salmon's And Warner's

Doane Valley

SilverCrest

Planwydd

Indian Tepee.

Mail Trail

Palomo Creek Bathers

Inspiration Point.

Nate Canyon

Booker Hill

- - - - Trails.
———— Roads.
∼∼∼ Running Water

Issued by Palomar Mt. Good Roads Assoc.

For additional information about places of interest on Palomar ask the manager of any of the resorts on the mountain.

PALOMAR MOUNTAIN GOOD ROADS ASSN.
June 25,26, 1921

Welcome to the Shire. Like a page out of Tolkien, these early runes chart the mountain's Middle Earth as a land of haunts and hollows, mysteries and magnificence. Once upon a time, long, long ago, before government-funded roadways, right-of-ways, easements, and conveyances, these hand-hewn tracks and trails marked many paths less traveled.

On the Cover: Resort guests in 1924 gather for the evening event as bonfire flames dance into the nighttime sky; spiraling sparks mix with stars that somehow shine more brightly here. For eons the mountain has served as home, haven, and hideaway for pilgrims such as these, drawn to the confluence of heaven and earth, a mile in the sky. (Courtesy of the author.)

IMAGES
of America

PALOMAR
MOUNTAIN

Brad Bailey

ARCADIA
PUBLISHING

Published by Arcadia Publishing
Charleston SC, Chicago IL, Portsmouth NH, San Francisco CA

Printed in the United States of America

Library of Congress Control Number: 2009921927

For all general information contact Arcadia Publishing at:
Telephone 843-853-2070
Fax 843-853-0044
E-mail sales@arcadiapublishing.com
For customer service and orders:
Toll-Free 1-888-313-2665

Visit us on the Internet at www.arcadiapublishing.com

For Terri

CONTENTS

ACKNOWLEDGMENTS

To pay tribute to the many contributors of this volume is to recognize both those who have worked directly with me and the many folks who left us with this rich heritage atop Palomar Mountain.

To the former group, many thanks to Debbie Seracini, my editor at Arcadia Publishing, and to my neighbors and fellow legacy-ranchers Wog Bergman, Dutch Bergman, and Jim Mendenhall. Palomar Mountain Fire Department chief George Lucia and fellow Palomartian Shirley Thompson have been invaluable sources of material. Scott Kardel at Palomar Observatory, Glenn Steckling of the Adamski Foundation, and Bob Thicksten all graciously assisted in documenting the call to high science and outer space. Peter Brueggeman and Jim Newland both took time to meet with me and referenced rich collections of material. Closer to "the home place," Dave and Janet Bailey Andersen of the Bailey Historical Society LLC; Steve Bailey, who had the foresight to archive family material long ago; and Matt Bailey of Palomar Mountain all have my gratitude and appreciation for their endless consideration, kindness, and support in preparing material on our family's century and a quarter upon the hill.

To the latter group, my lasting and heartfelt appreciation for the many family members, friends, and neighbors who are no longer with us, but through whose efforts and endeavors (intentionally and otherwise) we have all benefited. Especially to the pioneering women, past and present, who have consented to be married into, for better or worse, the backcountry, working legacy-ranch lifestyle and whose presence here on the mountain have made this continuum possible. Personally, and with eternal gratitude, I would like to thank Mary, Adalind, Doris, Terri, and Vandy.

The images in this volume appear courtesy of David P. Andersen (DPA), C. H. Bergman (CHB), Matthew T. Bailey (MTB), fire chief George Lucia (CGL), Palomar Observatory/California Institute of Technology (CIT), USDA-FS Cleveland National Forest (USFS), G.A.F. International/Adamski Foundation (GAF), and unless otherwise noted, from the author's private collection.

INTRODUCTION

This is a work of images intended to convey a historic perspective of this community and provide the reader with a sense of time and place. A brief tourist guide to the area might read as follows.

Palomar Mountain is one of the most striking natural environments in Southern California. Rising over a mile into the bright western sky, its steeply forested south face offers unparalleled vistas of the blue Pacific Ocean far below. It is a place of rich forests, dripping springs, and the finest artesian waters on the planet. The mountain is largely wilderness and mostly under the control of state and federal government agencies. Palomar is located about 30 miles inland from the Pacific Ocean and 60 miles north of San Diego, California. The small population is dispersed along the southern summit and supports two private communities. To the east, the small enclave of Birch Hill is also known as Crestline for its single, paved roadway. To the west is the tiny subdivision of Baileys. Northward is the Palomar Observatory compound, which is a self-sustaining community in its own right. Just two paved roads service the area, running orthogonally north-south and east-west, both terminating in dead-ends. The mountain supports a store, post office, and restaurant, plus a state park, various federal and county campgrounds, and a few private camp and resort facilities. Several ranchers work tracts of lush, sheltered valleys behind locked gates accessible only by rutted dirt roads.

Yet to live on this remote mountaintop in Southern California, along with a couple of hundred others in full-time residence, is a singular experience within an equally rare environment. Over half a century ago, a widowed grandmother lived here as the sole occupant of her family's former resort hotel. She always referred to it as "the home place." To a visiting youngster, the view of Palomar Mountain through that nimbus seemed a rarified vision, simultaneously the stuff of belonging and beguilement.

For decades the old woman lived within what seemed like an old ghost town all but abandoned to the fates long ago. With her blessing, visiting children would play "store" in an abandoned century mercantile, its shelves still stocked with canned goods and rolls of brown wrapping paper gone crisp with age.

In the drawer of an ornate brass cash register, there were little notes written on scrap paper—perhaps a promise quickly dashed off by a neighbor short on change long ago. From above, a framed Norman Rockwell of "President Ike" smiled down like a kindly grandfather figure. The portrait still dutifully hung in the tiny cubbyhole post office once known as "Nellie, California."

In the evening, one would be invited to sit before a massive stone fireplace in the old woman's overstuffed and faded chair, while other visitors chatted in the tiny kitchen nearby. In the former lobby of this turn-of-the-century backcountry hotel were the leather-bound, heavy black paper pages of her family albums. She had always kept them there next to the ancient stone hearth under back issues of the *Saturday Evening Post* and *Collier's* magazines.

On those pages, peering out from within tidy triangle borders, were folks from days long past; one on horseback clothed in overalls, another behind the wheel of an open-top touring car sporting a fedora, bow tie, and broad smile. At one time they had been a part of the mountain and had created the amazing world that remained decades later.

As documented in black-and-white images, the town dated back to the late 1800s but now seemed to be quietly sleeping off oblivion within this forested mountaintop backwater; the terminus of three dead-end roads. From these album pages, a family of hardy settlers stand proudly before their newly completed adobe homestead, actually just a hovel of mud and hand-split cedar shakes. The 100-feet-high cedar trees towering out front today were mire saplings back then.

Here were the six children who helped patty-cake walls of plaster-coated soil, thus literally making Palomar Mountain their new home. Turn the page, and the kids have grown to adulthood. One of the brood has created a delightful destination resort from those humble beginnings, eventually marring a beautiful and demure hotel guest. Turn the pages again, and the glowing Victorian bride-come-hostess is now pictured gray with age next to the same family hearth.

Education of this sort was not taught formally on the mountain. Local stories, traditions, and legends were picked up piecemeal through short, often funny, anecdotes and snippets of information told over kitchen counters or from front porch rocking chairs. The few collections still in existence are a hodgepodge of stories, photographs, maps, postcards, and all manner of bric-a-brac; packed away in sagging cardboard boxes for a time and purpose still undefined. Some materials might be copied from a widow up the road, others discovered in boxes of pictures half-buried in the old community dump; perhaps the last vestiges of an old-timer's life on the mountain, no longer valuable to the realtor preparing a little cabin for sale.

Yet, the true color of Palomar Mountain is more subtle and intriguing than mere collectables. It can best be found in the fabric of the lives and stories woven by those who have peopled this unique community in the past and by those who carry on much of the same traditions today.

The following is a small collection of photographs and memorabilia mostly from the author's modest archive. The content has been arranged to help convey a story that, due to the nature of the format, revolves around the images at hand. Many important and worthy subjects are not included here, either for lack of an appropriate picture or because of the limited space available in the work. Nonetheless, the effort is intended to be a tribute to the mountain and all its people, past and present, in appreciation of this truly unique, compelling, and timeless oasis in the sky.

One

IN THE BEFORE TIME

As a link in California's Pacific coastal range, the mountain is an island as certainly as her offshore sisters San Clemente and Santa Catalina are, and as such supports a unique environment held willing captive over a mile in the sky. Once as barren as a glacier, the introduction of flora (from lichens to oak forests) combined with copious amounts of rainfall, gradually transformed stone crevasses into subterranean water-storage tanks. There a rich blue-green clay material formed from the resulting weak acid bath being in contact with the mountain's granite substrates.

Seeping downward over millennia, clay sealed off the fissured natural drainage, thereby creating deep subterranean grottos of pristine water. This resulted in a mountaintop environment that weeps forth the finest water on the planet from a myriad of artesian springs. These in turn support stunning microclimates and a natural life force, both rich and grand.

The first people to behold this primeval wonderland, lofted high above the arid desert, journeyed here from afar many thousands of years ago. Although archeological evidence supports disparate waves of human habitation throughout the Americas spanning thousands of years, the earliest historical record of the area begins with the Spanish occupation of Alta California some two and a half centuries ago. The native peoples on and around the mountain were known as "Luiseños" by Spanish missionaries, due to their proximity to Mission San Luis Rey some 30 miles down valley toward the Pacific Ocean. Rugged, foreboding, wild, and rich, Paauw (the mountain) was, even then, recognized as an amalgam of geography, climate, and rare spiritual significance.

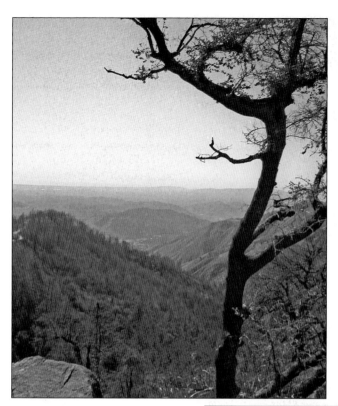

GATEWAY TO ENCHANTMENT. Of the mountain's many diverse environments, Pauma Creek may be the first among equals. Gazing downward from the west precipice, known as Ta'I, to the local Luiseños, this shear and tumbling canyon supports nearly vertical forests folded into a 3,000-foot cleavage, forming the massive southwest approach to the mountain. From its headwaters, Pauma Creek offers up a crystal cascade, which leaps downward through a latticework of polished granite, shaded by moss and covered forests of hanging bayonet and bracken fern.

BEYOND HERE THERE ARE DRAGONS. Pauma Creek's astonishing beauty cloaks a hidden, insidious side. The rugged terrain can be exceedingly dangerous and maintains a sinister reputation to this day. A century ago, historian of Native American lore Philip Sparkman recorded tales of "a being known as koyul" that lurked in Pauma Creek. The size of a man, it "looked like a very large toad" and objected to people near its abode.

IT's THE WATER. Known as Paisvi to the native people, Iron Springs is one of many naturally occurring artesian springs on the mountain. These were virtual Edens to the early nomadic residents, and each is characterized by a particular quality of the waters. The ocher-colored residue deposited at the stone outflow indicates high concentrations of ferrous material just below the surface.

Amazing Trees of Mystery. At a mile high and often shrouded in clouds, Palomar erupts in lush meadows and rich forests scarcely believable to those accustomed to Southern California's arid environment. Thick stands of fir, pine, spruce, cedar, and a variety of stately oaks checker the landscape. Towering just under 200 feet tall, giant incense cedars in Doane Valley dwarf the photographer's Model A Ford truck parked at their base. Palomar has been a ready source of timber for centuries. Felled by ax and carted by oxen some 30 miles to the southwest, huge timbers from the mountain were incorporated into the construction of the magnificent San Luis Rey Mission, founded in 1798.

IN THE OFF-SEASON. For thousands of years, ancient peoples were merely seasonal residents of the mountain. As the forest foliage turned to autumn gold they would pack up mortar and pestle, basket and bowl, and migrate down to the valleys below with their bounty in tow. Although acorn meal was a bulk staple and trade commodity, the mountain also supplied wild berries, nuts, fish, fowl, and venison to round out the harvest. Paauw was then left to her long winter's sleep under a cold blanket of white. The alpine climate that supports this island in the sky winters quietly like many places in more northern latitudes. One difference, however, is the view off the southern summit on a clear winter morning where the blue Pacific Ocean sparkles against the mild, sunlit shore far below.

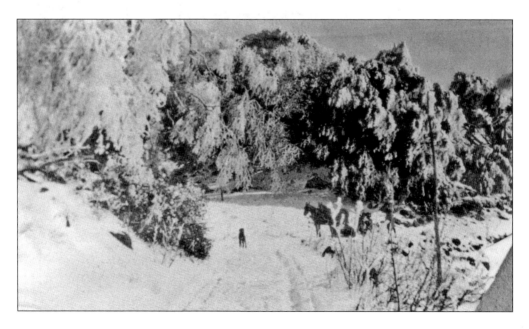

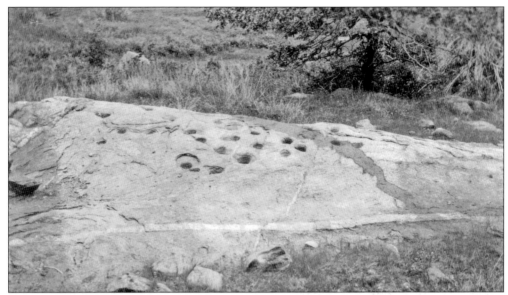

The Daily Grind. Local Native Americans created numerous multi-holed mortar stones atop the mountain, such as this specimen from an early Palomar postcard. Usually located near a spring-fed water source and under shade trees, these stone factories or grinding flats were used to crush acorns and small seeds into meal for fun and profit (consumption and trade) over the centuries.

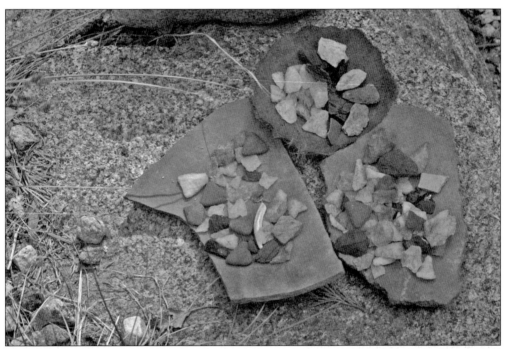

Sign of the Times. Most large grinding flats were the operations center of a large and well-organized social group. Today one finds the nearby soil black from campfires dating back to unknown times, and the ground about is scattered with pottery shards and arrowhead tailings like those shown above. The pressure-flake manufacture of arrow points from native stone required considerable skill and a source of quality material, usually native white quartz. (MTB.)

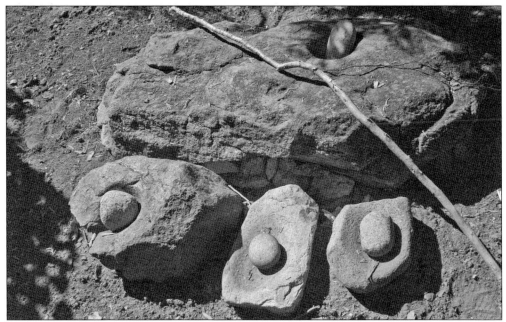

PORTA-MORTARS. Rather than take the acorns to the grinding stone, potable mortars were often carried to a remote site, there to render the local nuts into meal. Crushed acorn flower was far easier to transport to the central gathering zone than lugging baskets of nuts back to the big grinding flats. Here three mobile mortars are shown adjacent to a stationary, although minor, grinding flat. (MTB.)

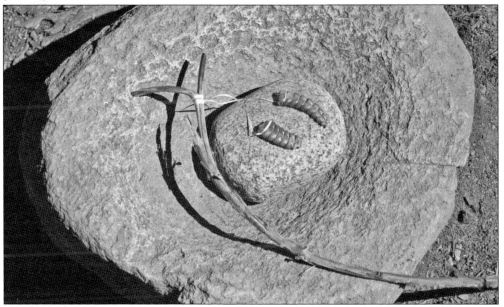

HOUSE CALLS. Drawing from Sparkman's writings, "The … medicine-men are nearly all doctors. An Indian has faith in the supernatural powers of the medicine-men. A Cahuilla doctor is said to have sucked a rattlesnake about a foot long out of a woman's chest. They... sometimes [use] a stick with a number of rattlesnake rattles tied on one end. Some of them must either be sleight-of-hand performers, or else possess the power to hypnotize." (MTB.)

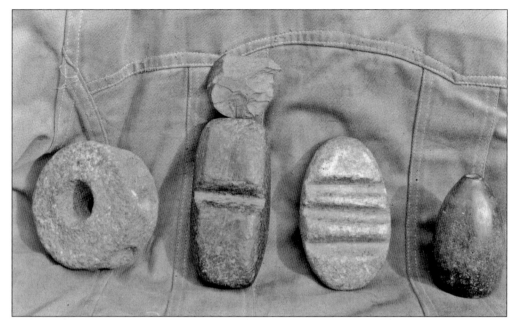

NAME THAT TOOL. An early glass-plate photograph by Robert Asher displays a collection of stone tools from the Palomar area. These have been identified as, from left to right, a digging weight, a small cutting implement, two arrow straighteners, and an early smoking pipe, perhaps called a "hukapish."

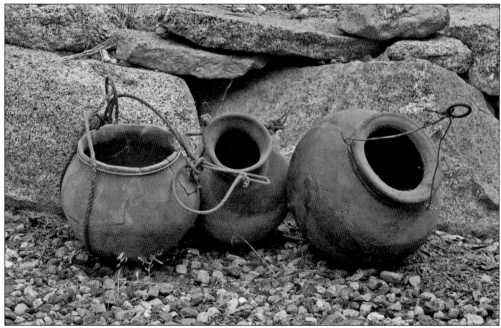

LARGE MOUTH CLAY JARS. Sparkman continues on local pottery, "Several different kinds of earthen vessels are made, the commonest form . . . for keeping water cool, and . . . storing seeds. This is called [a] narungrush. A form of vessel with an extra wide mouth, wiwlish, is used for cooking food, another with a small mouth, nadungdama, for carrying water. . . The Luiseños never [made] handles for their pottery or baskets." (MTB.)

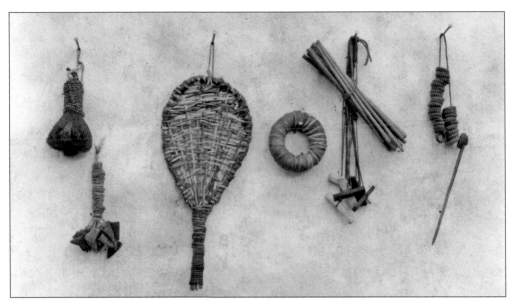

THE OLD WAY. These two Asher glass plates were exposed almost a century ago without commentary. At about the same time, writing by kerosene light behind his Rincon Springs General Store, English ex-patriot Phillip Sparkman further describes Luiseño articles made of plant fiber. "A large-meshed net for carrying bulky or heavy articles, ikut, is . . . made from twine. This [is] passed across the forehead . . . A net-work sack for carrying acorns, kawish, was . . . sufficiently small to prevent the acorns from falling through. A long net, yulapish, for use at rabbit drives . . . were considered very valuable. A draw-net for catching . . . jackrabbits was also made [and a] small fine-meshed dip-net was . . . for catching a very small fish."

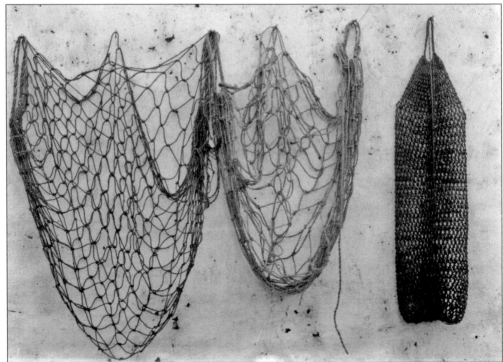

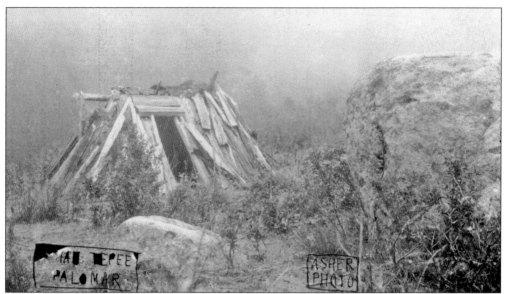

Fog Shrouded Habitat. Now long relegated to the mists of time, this ridge-beamed, cedar bark lean-to (possibly a sweat lodge) was captured by Asher's glass-plate camera over a century ago. The emulsion crudely scratched in his field darkroom identifies the photograph, but its exact location is lost to history. Long neglected, only a handful of these seasonal structures remained when the photographer documented an all but vanished way of life.

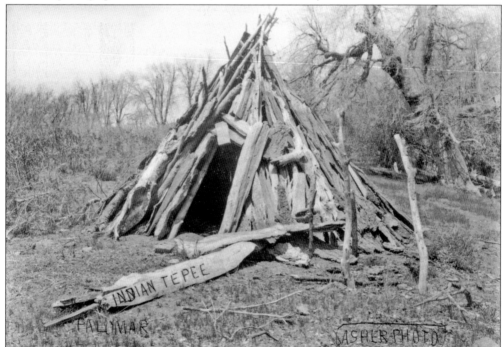

Last of Its Kind. High on the must-see list for mountain visitors in the early 1900s, this authentic, cedar-bark tepee was one of few remaining by then. Once summer homes, the Luiseños called them "kecha kachumat" or pointed house. Each spring, these people migrated to the mountain's summit from the valleys below to hunt, collect berries, and grind acorns in dozens of spring-fed camps.

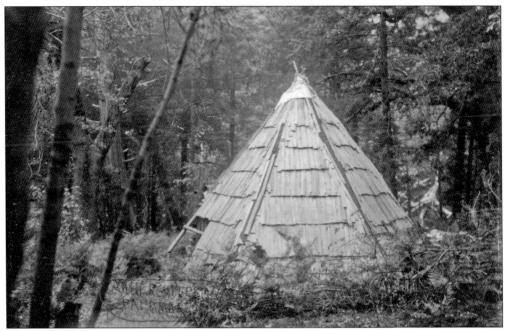

CONE OF SILENCE. Nestled deep within what is now Palomar Mountain State Park, this handmade cedar-shake tepee invokes images of a time long past. Inspired by traditional Native American cedar-bark tepees still standing on the mountain at the time, Asher fashioned this modern structure with local materials in the early years of the 20th century.

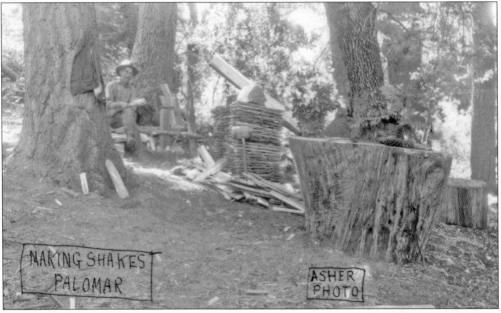

SHAKE IT UP. Wooden mallet in hand and shingle-wedge (or fro) at the ready, Robert Asher takes a break at his homemade cedar-shake factory in the early 1900s. Born in 1868, he was introduced to the mountain by homesteader Theodore Bailey. Asher nurtured a love affair with the mountain that provides a rich legacy in stories and glass-plate photographs. He built this forest camp in the tradition of John Muir, who championed the Yosemite Valley during the same period.

19

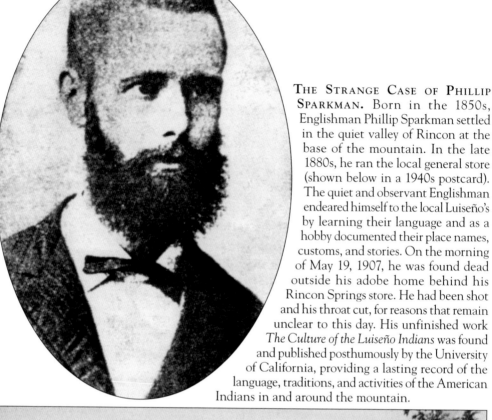

THE STRANGE CASE OF PHILLIP SPARKMAN. Born in the 1850s, Englishman Phillip Sparkman settled in the quiet valley of Rincon at the base of the mountain. In the late 1880s, he ran the local general store (shown below in a 1940s postcard). The quiet and observant Englishman endeared himself to the local Luiseño's by learning their language and as a hobby documented their place names, customs, and stories. On the morning of May 19, 1907, he was found dead outside his adobe home behind his Rincon Springs store. He had been shot and his throat cut, for reasons that remain unclear to this day. His unfinished work *The Culture of the Luiseño Indians* was found and published posthumously by the University of California, providing a lasting record of the language, traditions, and activities of the American Indians in and around the mountain.

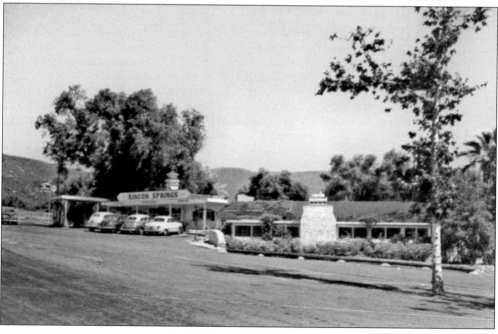

Two

RUSTLERS AND RANCHERS

Settling the fertile San Luis Rey River Valley in the 1780s, Spanish missionaries referred to "Sierra de Palomar" as the blue band of mountains rising far to the east. The mountain was too remote and inaccessible to sustain an economy as such but was an ideal refuge for those on the fringe of society in the turbulent years following the acquisition of Alta California by the United States.

This period of California history is notorious for lawlessness. In the early 1850s, safe travel in the area required the company of a dozen armed men, as random roadside thievery and bloodshed were all but expected. The mountain often served as a way station for trade in stolen livestock and a hideout for desperados.

Amidst these wild and desperate times, two pioneers emerged who would beget a ranching legacy spanning the better part of two centuries. Enos Thomas Medenhall's life story reads like a western adventure novel. Born in North Carolina in 1822, the former schoolmaster came west by wagon train in 1847. Around 1869, Enos arrived in Southern California, eventually finding the fertile valleys of Smith Mountain (as it was then known) much to his liking. Up to that time, land rights were known as a "six-shooter title" often enforced by renegades and wanted men.

Equally rich in deed, although less documented, is the story of Jacob "Dutch" Bergman. A rugged individualist, adventurer, and frontiersman who the San Diego *Tribune* said "held the reins in 1858 on the first westbound Butterfield coach to cross . . . the western desert . . . [of the Overland] trail." Later wounded in the Civil War, Bergman returned to the area and ranched near the Butterfield route north of the mountain.

In the boom and bust economies that characterized the old American West, most attempts at rural farms and ranches resulted in tattered shambles. Today the combined legacy of these two early ranchers demonstrates a dedication to purpose, profession, and the cattleman's trade. Legacy-ranching on Palomar Mountain is a testament to perseverance in the face of the ever-changing and ever-challenging business and environmental climate.

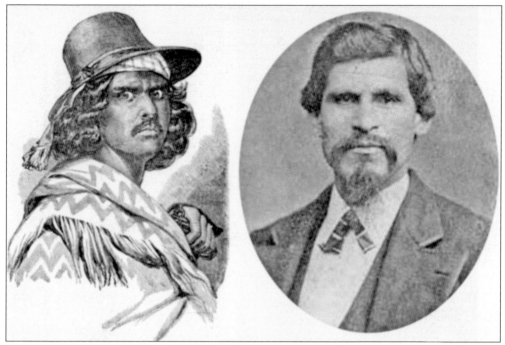

LOS PISTOLEROS. From a lofty, primeval paradise to a haven for the accused, Palomar was a backdrop for the turbulent drama of mid-19th-century California. In 1857, a government posse was dispatched to the Palomar region with instructions to hunt down highwaymen operating in the area. This included self-styled *insurrectos* such as Juan Flores (above, left) and Tiburcio Vasquez (above, right). Still controversial, the *insurrectos* waged a self-serving struggle against American and foreign-born settlers of the region.

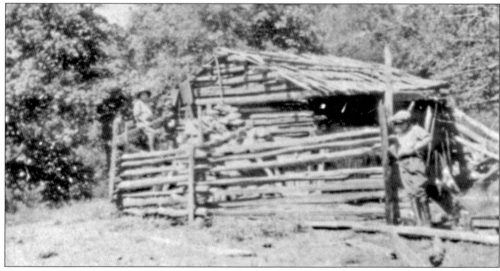

OLD-TIMER'S HIDEAWAY. With its difficult access and hidden valleys, the mountain served as a hideout for bands of roving desperados for decades. Old stories of murder, hidden graves, and buried treasure color the mountain's early history. Well into the 1900s, backwoods explorers (above) would occasionally stumble upon an abandoned or "hidden" cabin that may have served dark purposes in times past.

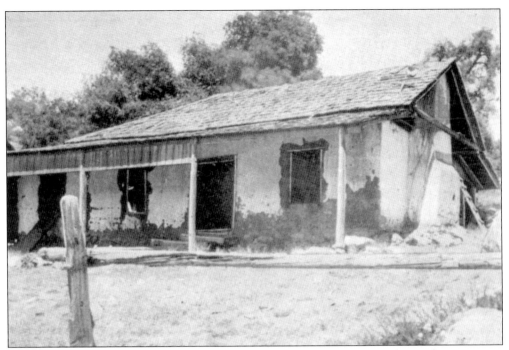

LONG JOE SMITH. In 1856, Joseph Smith built this adobe, ranching a wide valley on the mountain's eastern side. He was found murdered not far from the house, and his newly hired itinerant worker was immediately accused of the deed. Smith was popular, and backcountry justice was swift. The stranger was hanged for the crime the following day at nearby Warner's Ranch. As a tribute, the native name Paauw became Smith Mountain.

CRYING WOLFE. Smith Mountain ranches served the Butterfield stage route north of the mountain. In the 1860s, a former stage driver called Wolfe built a small ranch in highland Malava valley. Wolfe met his demise at the hand of a jealous husband, also a former stage driver. The husband buried the unfortunate Wolfe in a split-cedar box in the dead man's garden. A colorful legend says Wolfe's spirit still guards his final resting place.

JACOB "DUTCH" BERGMAN. Driving the Butterfield stage over "a 24 day trip through hell" was a formidable job. In 1858, Dutch Bergman drove the first of these to cross the western desert. After serving in the Civil War, he returned to the area and ranched along the stage route north of the mountain. Six generations later, the Bergman family continues to call the mountain home. (Courtesy San Diego Historical Society.)

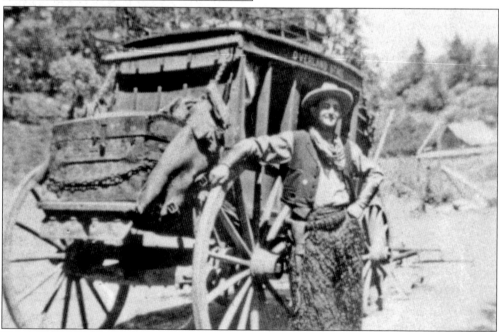

HOLLYWOOD HERO. Almost half a century after the actual events, the mountain again plays host to an overland stage adventure, Hollywood style. Actor Dustin Farnum sports cowboy regalia during the filming of Owen Wister's 1902 novel *The Virginian*. Directed by the famed Cecil B. DeMille, the 1914 silent film brings the quintessential western novel to the silver screen, here with Bailey's Resort as backdrop.

ENOS T. MENDENHALL. Enos Thomas Mendenhall's life was one of heroic western adventure. Having come west from North Carolina, he settled in a fertile valley on Smith Mountain in 1869. The ranching enterprise he founded would eventually grow into the Mendenhall Cattle Company, a family enterprise still in operation on the mountain some 150 years later.

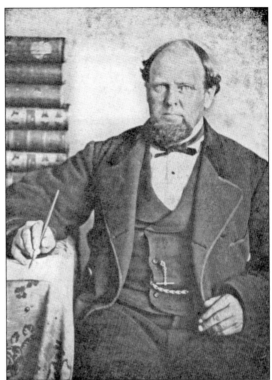

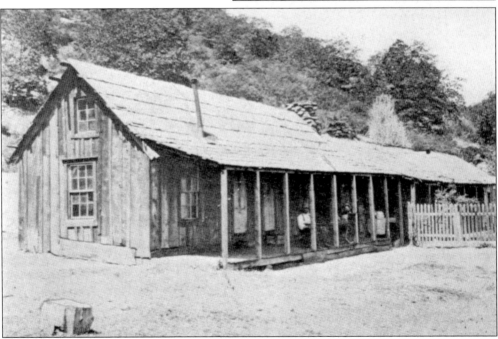

EARLY MENDENHALL RANCH. Originally the John Place home, Mendenhall acquired this and other settler holdings on the mountain that would evolve into a six-generation ranching legacy. The original Mendenhall Cattle Company headquarters near the Malava artesian spring were said to be constructed from boards milled by an early steam-driven sawmill.

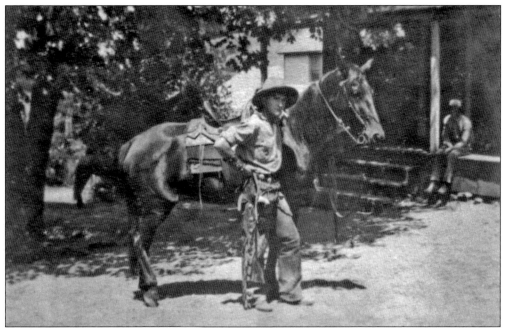

"WHEN YOU SAY THAT, SMILE." Turn of the century Smith Mountain, as it was then known, sported cattle ranches and a posse of working cowboys. This particular specimen, seemingly cut from the pages of *The Virginian*, was captured by a glass plate camera at the Nellie Post Office and General Store located at Baileys.

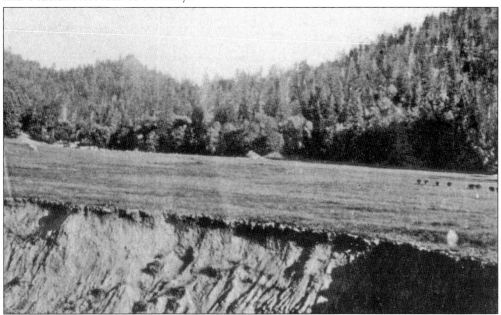

BIG SKY COUNTRY, SOUTH. The mountain's lush French valley begs comparison to the rangelands of Wyoming. Like northern cattle ranches, driving livestock is essential to business. Today Bergman and Mendenhall cattlemen repeat the time-honored traditions of branding, roundup, and cattle drives between winter and summer pastures. Palomar Land and Cattle Company now manages thousands of acres of prime grazing land, much as the family's forefathers did over a century ago.

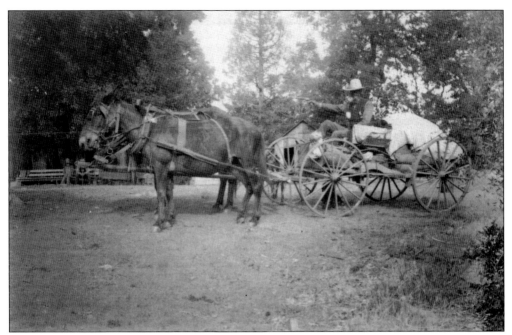

SIX-CYLINDER MOTIVATION. Early mountain rancher Jim Frazier, six-gun in hand, makes his intentions known to this reluctant mule team. Freight was hauled to and from the mountain over steep, rocky, and often dangerous roadways. It was typical to tie a fallen tree to a wagon while descending the torturous mountain grades, which would then serve as a makeshift break.

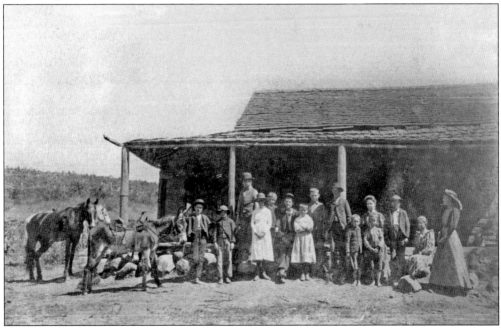

SUNDAY GO-TO MEETING. Dressed in their finest attire, members of this remote community gather for Sabbath observances in the late 1890s. Religious gatherings were an important social component on the mountain. Weekly services also provided a respite from the rancher's lifestyle and the incessant labors required to make a living off the land.

ASPIRING TALENT. Carl "Wog" Bergman was born into the mountain's cattle business. Shown here around 1947, he is the great grandson of original Palomar ranchers Enos Mendenhall and Jacob Bergman. These two pioneering families were united by marriage and common purpose in 1917, when Wog's parents, Annie Mendenhall and Orlando Arlie Bergman (both founders' grandchildren), were married. Annie lived to celebrate her 100th birthday with family and friends in 1995. (CHB.)

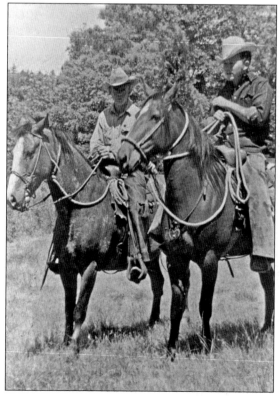

CONFERENCE IN THE SADDLE. A generation later, Wog Bergman (right) managed the legacy-ranch for his widowed mother, Annie Medenhall Bergman. By the 1950s, the enterprise had evolved into Palomar Land and Cattle Company. Jack Mendenhall, Wog's cousin (left) confers on horseback during a break from the chore d'jour. (CHB.)

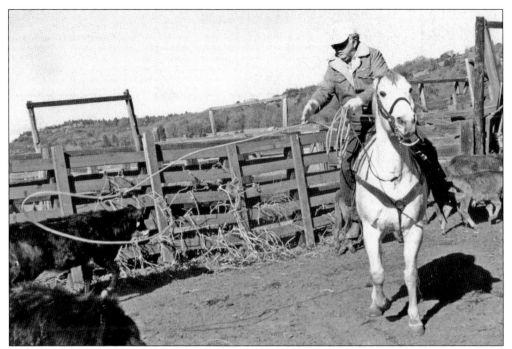

MASTER STROKE. Demonstrating the expert proficiency gained from seven decades in the business, Wog Bergman's lariat finds its target during spring calving on the mountain ranch. The Bergman and Mendenhall ranching legacy has worked Palomar Mountain's mile-high pastures and forests for some 14 decades. Palomar Land and Cattle Company and other family ranchers manage thousands of acres of rangeland, some with original split-cedar drift fencing and century-old hand-hewn stock pens that are still in use today. (CHB.)

LIFE CHOICE. "I don't think many people would choose a rancher's lifestyle, especially when you consider salary," muses Curtis "Dutchy" Bergman, here working horses in the Mendenhall Valley. As the great-great grandson of the original Dutch Bergman, the fifth-generation Palomar rancher oversees hundreds of head of livestock. Learning the ropes early is a painful requisite, as are the lasting effects of countless horse wrecks over the years. (CHB.)

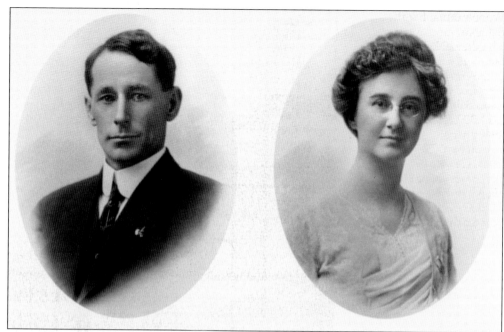

A Place in Time. In the mountain's early years, dozens of small ranches and farms were founded and later abandoned. Rancher Louis Salmon was not atypical. Born in Georgia in the 1880s, Salmon migrated to the area after the turn of the century. He eventually settled on the 1,000-acre Dyche Valley ranch. As a widower, he courted and eventually married Hodgie Bailey (right), daughter of an early Palomar settler.

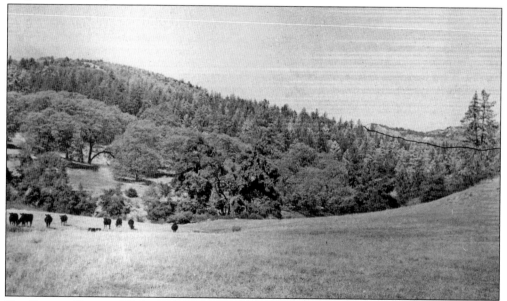

The Salmon Ranch. Working the 1,000-acre Dyche Valley plateau, Louis and Hodgie Salmon edged out a living in the early 20th century. Like many on the mountain, their business was subject to the ebb and flow of national economics. Known as "a pretty carefree guy" despite the Great Depression, Louis retained a consistent optimism in the face of the pending economic disaster that shadowed most ranchers in those years.

WOODWARDIA. For the Salmons, ranching was a hardscrabble business, but there was to be light at the end of the tunnel. Undaunted through it all, Louis Salmon gladly sold his 1,000 acres in the late 1940s, acquiring a tidy sum of cash for those post-war years. He then built Hodgie her dream adobe home, Woodwardia, and bought himself a new Cadillac every year for the rest of his life.

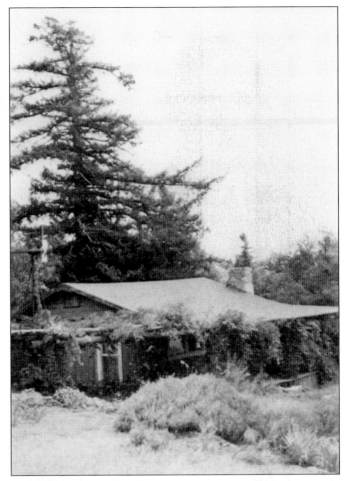

LATENT TALENT. Carved out of their former ranch property, and offering a spectacular vista of the Pacific far to the west, the Salmon's home, Woodwardia, gave Hodgie time to pursue her passion of landscape painting. Self-taught, she created astonishing works of oil on canvas (such as this panorama from her south patio) that are prized today.

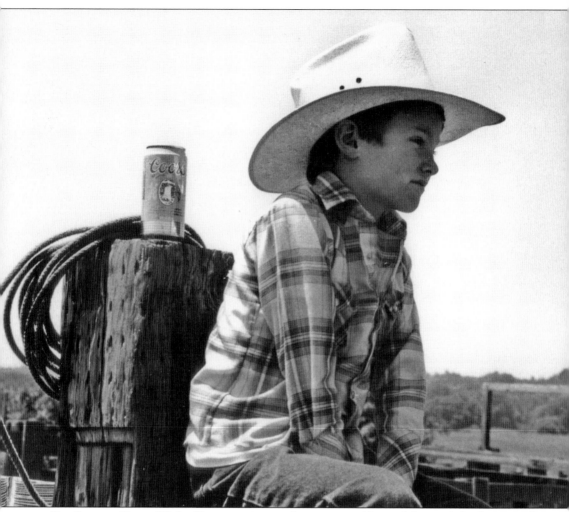

THE LEGACY. Young Wesley Bergman sits astride a century-old corral fence while observing the mechanics of the cattlemen's trade. He personifies six generations of Bergman/Mendenhall family ranchers, which continue to work mountain land their forbearers wrested from the lawless wilds. Cattle "are the continuous thread that runs through the 150 year history of the family," says Dutchy Bergman, Wes' father and fifth-generation mountain rancher. Yet maintaining a viable Southern California agriculture operation "is a huge challenge," he continues. As a presence, Palomar ranches represent triumph over adversity. In practice, however, the mountain's ranching lifestyle faces an uncertain future. More of a calling than a career, legacy-ranching today is, as one old-timer puts it "really a labor of love, with the emphasis on labor." (CHB.)

Three

SETTLERS AND SODBUSTERS

Eighteenth-century America was a mostly agrarian society with over 85 percent of the population living off the land in some fashion. The Homestead Act of 1862 sought to encourage settlement of the Old West. For a modest filing fee, 160 acres of land was available to anyone who was at least 21 years of age and the head of a household.

The law required that the land had to be "occupied and improved" for five years, after which the homesteader would gain ownership. Due to its extreme southwestern location, settlement of the mountain by homesteaders came relatively late in the century. Nonetheless, the incentive attracted many to federal lands on the mountain.

No doubt, Palomar's open meadows of bracken fern with forests of mixed hardwoods and conifers reminded eastern-born settlers of the home they left behind. Unfortunately, the similarity also extended to the winters on the mile-high mountain, which could be brutal to those who negotiated the backcountry roads and steep unimproved grades. The nearest town was at least a day's ride away. More than one early citizen was snowed-off the mountain just as others would become snowed-in.

Homesteader Theodore Bailey, one of many settlers during this period, and his young family wintered their first year in a hastily built log cabin tucked in a small valley atop the mountain. Theodore was off the hill when a storm covered the high country, and he was unable to rejoin his family for nearly a week. All through that first Christmas Eve in 1887, his wife Mary and their six youngsters did their best to survive the sub-freezing temperatures, as snow quickly buried the windows and the single door. Nanny, the eldest, organized sibling work parties throughout the long night. The kids shoveled off the cedar-shake roof, while the cabin ridgepole sagged under the excessive weight of the wet snow.

Catastrophe averted, the following spring the family completed an adobe home across their little valley, today known as the Bailey House. True to the law, five years later Pres. Grover Cleveland's signature adorned the property deed, dated May 12, 1892.

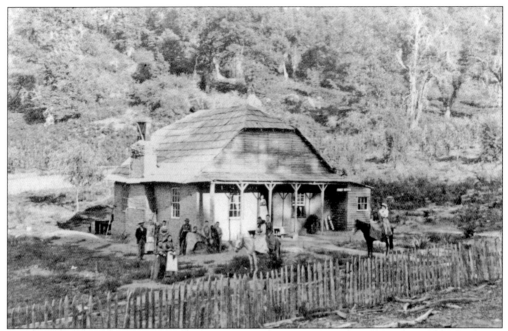

FROM THE CLAY UNDER THEIR FEET. Migrating to the mountain from their native Kentucky in the late 19th century, Theodore and Mary Bailey built this adobe homestead in the spring of 1888 with the help of the local Native Americans. Putting up the 9-foot-tall south wall of dried mud a foot thick, the family narrowly averted tragedy that first evening when the huge unsupported slab of earth toppled over in the night, fortunately falling away from the six youngsters who slept beneath it. The small sign to the right of the house reads, "Post Office." The Bailey place grew to become a focal point of the mountain community over the next seven decades.

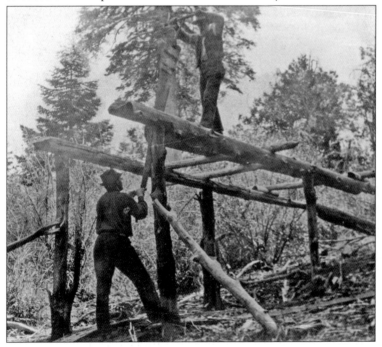

SAW PIT. With Theodore Bailey topside, a heavy beam is crafted from a local tree trunk. Everything traveling to the mountain was carried by horse and wagon, and tools were far easier and cheaper to transport up the steep mountain grade than finished material.

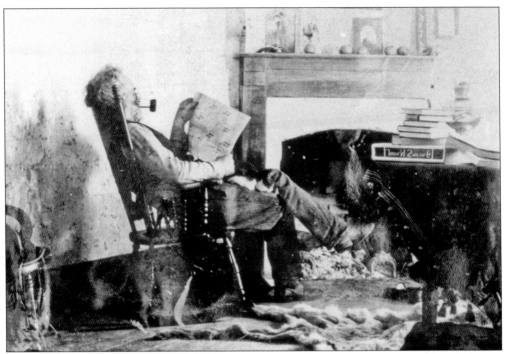

THE OLD HOME PLACE. "Father Bailey" reads the caption of this rare interior photograph of Bailey House when it was still a pioneer home. A surveyor by trade and county assessor by appointment, these early skills supported the homesteader family in the 1880s, while they sowed the seeds of sustainability in their mountain valley (note the puma-skin carpet).

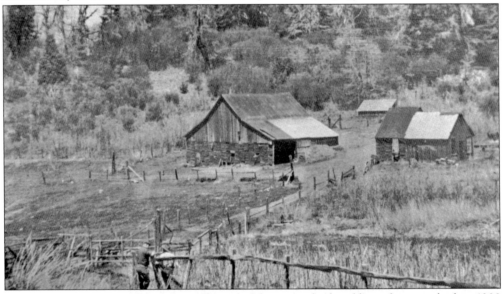

BAILEY BARN AND BLACK SMITH SHOP. Typical of the times, this hand-hewn barn was built in 1900 by Bailey and his teenage sons. Constructed of local oak with handmade cedar shakes, it originally housed the homesteader's livestock and later the Bailey Resort's guest horses. The subject of paintings and photographs for decades, this local landmark finally succumbed to a heavy snow in the winter of 1971. Adz scarred benches made from the oak beams now grace the porches of Bailey House.

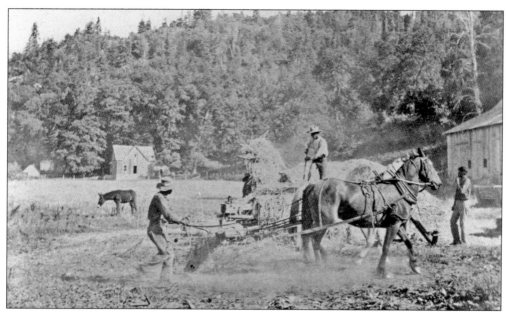

MAKING HAY WHILE THE SUN SHINES. Originally known as Power's Valley and home to an early steam-driven sawmill, this image of the Pedley Place optimizes the hardworking mountain settler of the late 1800s. Most early homesteads ran for a decade or so before the reality of the mountain's economics and logistics swamped the enterprise, usually resulting in abandonment of the properties.

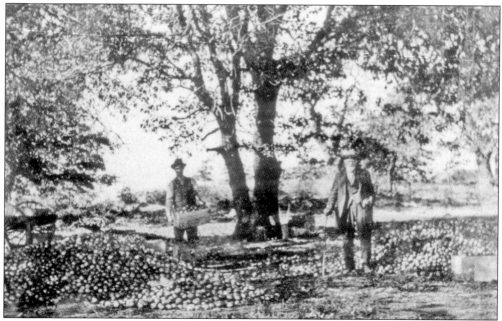

"APPLE RANCHING." Fickle as the weather, the mountain's apple economy provided needed capital in the days before refrigerated shipment. Although apple trees flourish on the mountain, crop yield is never assured due to Palomar's altitude and the vagaries of Southern California weather. This bumper crop must certainly have pleased Bailey patriarch Theodore (at right c. 1920), as the blessing of a cold winter was followed by a warm spring.

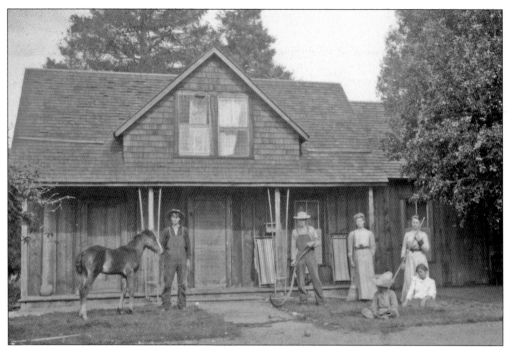

BUTTERFLIES NOT INCLUDED. Elsie and her husband, Jack Roberts, operated the Planwydd Hotel, once a butterfly farm, as a summer getaway. Elsie wrote vividly of her life on the mountain and left a family legacy that spans a century on Palomar. Later Elsie's daughter Katie with her husband, Chuck Beishline, hand-built a little weekend cabin at Bailey's, where the family toasted Elsie's 99th birthday.

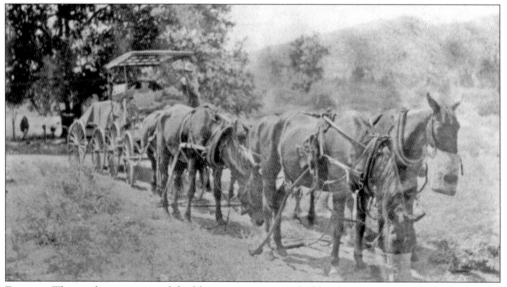

RESPITE. This six-horse team and double-wagon rig, typical of freight transport in the early decades on the mountain, takes a pause from their labors. As rugged as the uphill climb was on team and driver, the downhill run was more spectacular and potentially tragic. One low-tech defense against runaway rigs was to fix sled-type skids under the rear wheels, essentially dragging them downhill, destroying the sleds in the process.

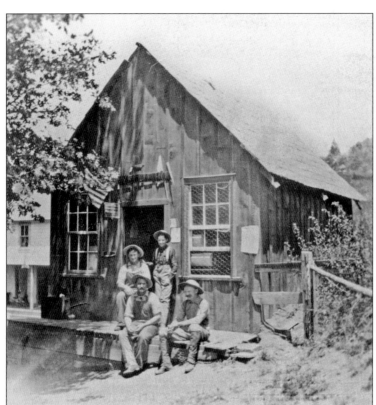

MINDING THE STORE. Named after an early postmistress, "NELLIE P.O." was the mailing address of then–Smith Mountain. The name migrated to the Bailey Store (here around 1900). Only dogged enterprise kept the many little mountain businesses afloat. As postmaster from 1888, Theodore Bailey was later instrumental in changing the name of both the mountain and the post office to "Palomar" around 1920.

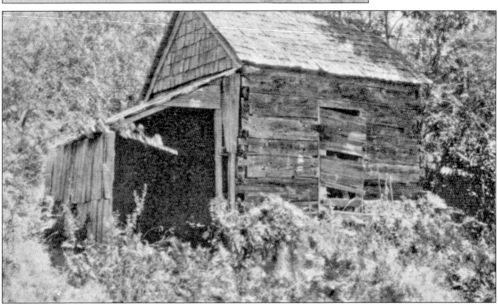

THE UNSINKABLE NELLIE McQUEEN. Reportedly, one-time postmistress Nellie submitted the name "Fern Glen" to the U.S. Postal Service. They then duly registered this early-mountain post office as "Nellie California" around 1883. The award of a post office contract was due mostly to partisanship, as postal appointments tended to be reassigned every few years based on the applicant's political affiliations.

MILLWRIGHT GONE WRONG. Various mill operations were attempted in the early years of the mountain. Although heavily forested, the high cost of material transport seemed to doom each operation from the outset. Another peril befell Dr. Milton Bailey in his partnership with a mountain mill operator who logged for a season and then absconded with the proceeds. With few options left, Bailey sold the mill and moved on to other endeavors.

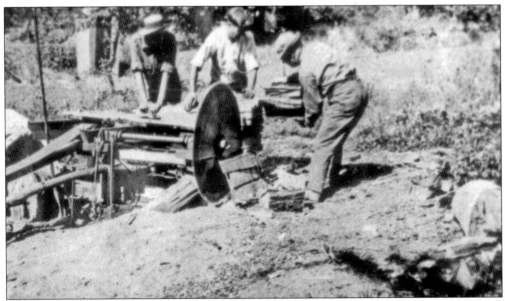

BUZZ OFF. Farming accidents were all too common in the days when family labor was a necessity of rural life. Here an open-framed buzz saw, powered by a potentially lethal flat belt, chunks off cordwood for the summer resort business in the mid-1930s. Years later, Adalind Bailey confessed she would busy herself in silent fear whenever her young boys were cutting firewood, never fully relaxing until the engine was shut down at the end of day.

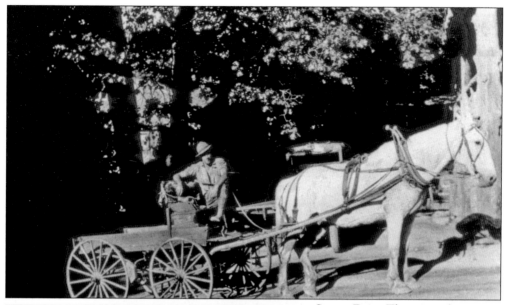

SWEET RIDE. The original handwritten caption, "Going a Girlin," speaks volumes as this unidentified bachelor swaggers for the camera in the early 1920s. Without electrical service, let alone today's entertainment media, social gatherings and events were an important part of rural life.

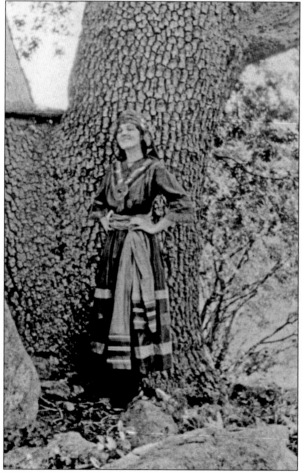

EXOTIC DANCER. Sporting a homemade costume, this beguiling Palomar resident radiates the confidence of a gypsy, sometime around 1919. Costume socials were a welcome diversion for members of this remote mountaintop community.

MILK RUN. Originating down on the farm, the youngsters shown here would later use this phrase to describe a low-risk mission into enemy territory. In these simpler times, the large milk cans clearly identified the mission goal.

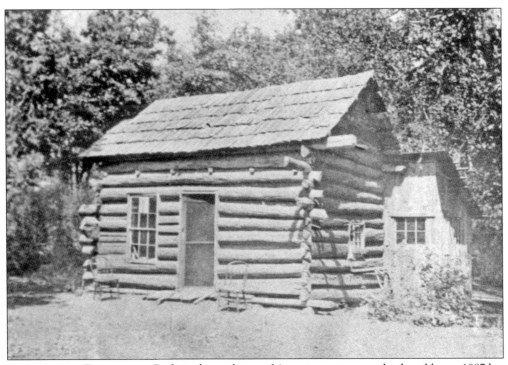

FROM HUMBLE BEGINNINGS. Built in the tradition of American pioneers, this hand-hewn 1887 log cabin sheltered the Bailey family through a 6-foot snowfall their first winter on the mountain.

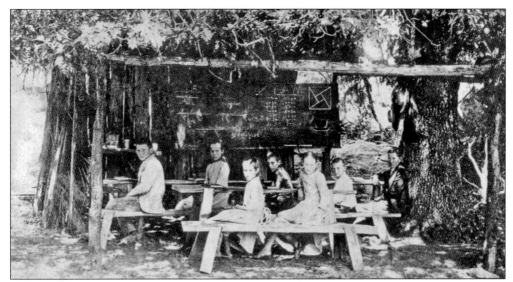

Mountain Outdoor School. Populated by the forbearers of current Palomar residents, this 1880s fair-weather schoolroom sufficed to launch many a remarkable career. The caption under this image published in another retrospective—*Women of the West*, C. Luchetti, 1982—indicates the teacher was too embarrassed by her situation to pose for this photograph.

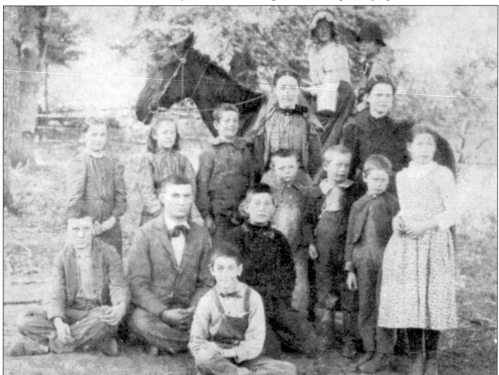

Picture Day 1897. These 15 Palomar students represent typical enrollment numbers on the mountain. The youngster at front, center, with the bow tie and infectious grin is Edward ("Happy") Mendenhall. This third generation rancher was glad to call the mountain his home then, now, and forever.

SCHOOL DAZE. Most memorable by far was the venerable Old School House located for decades near Sunday School Flat, named for the weekly devotions held nearby. Modern and well-appointed for the times, the building may have been acquired by mail order from Sears and Roebuck. Such buildings, shipped prefabricated via railcar, would have been hauled, piecemeal, up the mountain's steep grade and then assembled by community volunteers for the sole purpose of providing a quality environment for Palomar's small, but able, student body.

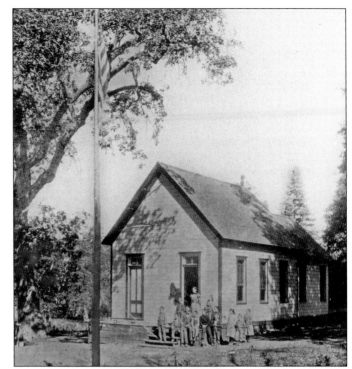

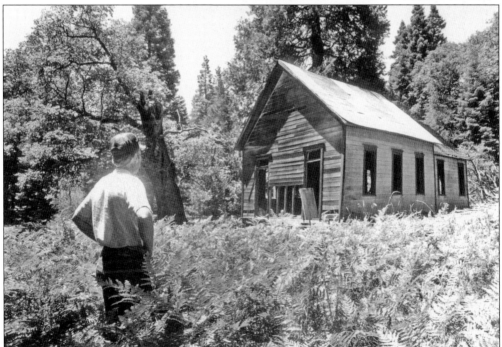

SCHOOL'S OUT. The passing of time and place tugs the heartstrings. In a modern world of budgets, mandates, and quotas, the Old School House stands empty towards the end of her life—a mute testament to the mountain's humble and honest beginnings. Long gone from the landscape, her fond memory still lingers in both image and heart. (CHB.)

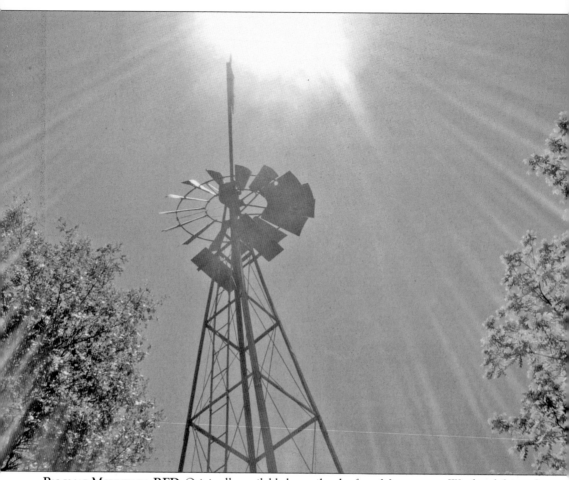

PALOMAR MOUNTAIN, RFD. Originally available by mail order from Montgomery Ward and shipped rural free delivery, this icon of Palomar's past has quietly watered farm and family for generations. Hefting a column of the finest spring water from deep within the earth, this machine employed the "greenest" of technology, long before it was in style. Originally erected by Chuck Beishline near the site of the old Planwydd Hotel, today this mechanical marvel of the times quietly wheels over Bailey Meadow. Here it shadows the spirits of those who came before, and who left the mountain a better place for their labors and their love. (DPA.)

Four

HOOTS, COOTS, AND RECLUSES

"I'm not a hermit, I'm just hard to find." Homesteader Gustav "Gus" Webber's sentiment self-describes a class of mountain personage who were drawn to the simple, quiet, self reliant, and solitary lifestyle that is Palomar Mountain. These endearing eccentrics tended toward the personable and gregarious, perhaps because of their socially uncluttered existence.

Although most were men, this phenomenon was not limited to bachelors. Many notable women willingly cut ties with mainstream life "down below" to call the mountain their home and safe haven. Often told is the story of two sisters, one a cripple, who built a secluded ranch and worked the mountain land at the turn of the last century. The sudden death of "Miss Maria" Frazier one afternoon left "Miss Lizzy" Frazier stranded in her chair for days unable to summon help. Mountain neighbors eventually learned about Lizzy's plight and quickly responded, handling the necessities, offering condolences and support, and leaving judgment to a power higher than themselves.

Today the modest population of Palomar boasts a demographic high in elders living happily and alone. There seems to be a certain joy and inner peace from a life of self-sufficiency and self-imposed seclusion high in the Southern California sky.

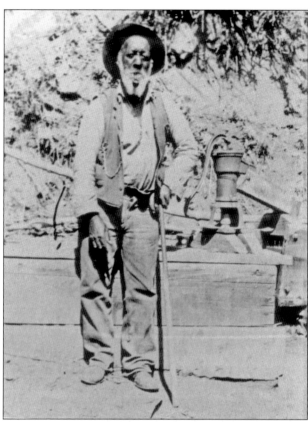

"First White Man on the Mountain." Undoubtedly the most beloved and well-known figure associated with early Palomar Mountain is Nathan Harrison. His story is almost mythical, as information from and about him differs widely. It's a virtual certainty that he was born a slave around 1820, probably in Kentucky. Once owned by a man called Harrison, Nate eventually settled on Palomar around 1850, calling himself "the first white man on the mountain."

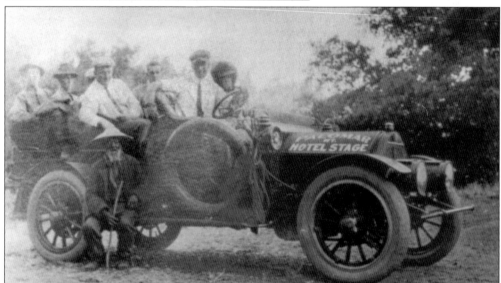

Loyal and Hardy Handshake. Volumes have been written about Nate and his life and times. Most include references to his nearly half-century-long stint as Palomar's unofficial greeter. Hailing all passersby, he would hand-carry water to thirsty horse teams (and later overheated automobiles) from his small spring on the mountain's steep and treacherous west grade that now bears his name.

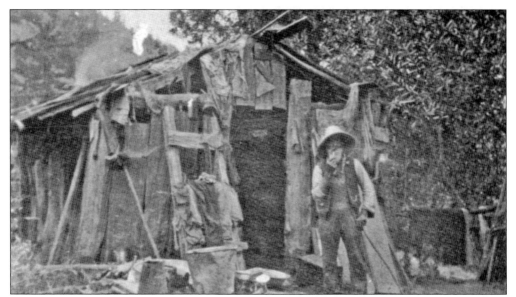

SHABBY SHEIK. Affectionately known as "Uncle Nate," Harrison might well be described as quite a character, and he was well aware of it. Said to be fond of whiskey, every New Year's Day he received a generous gift of spirits from an admiring neighbor. Being illiterate and lacking a sense of time as most people knew it, he would ask the neighbor how many days were left until January 1st, for the remainder of the year.

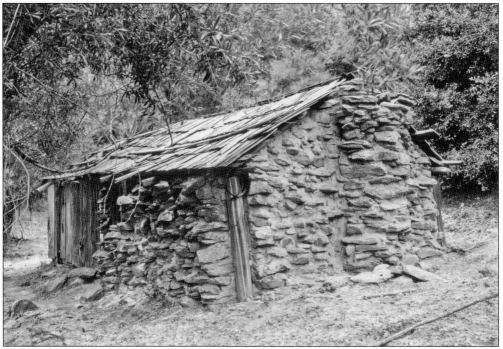

STILL LIFE. For years after Nate died in 1920, his hand-built shanty steadily succumbed to the elements. By then in his 90s, he was so encumbered by rheumatism that well-meaning neighbors physically relocated him to a hospital in San Diego. He was reluctant to go, leaving his few possessions in the cabin just as they were. Nate passed away within days, never having returned home.

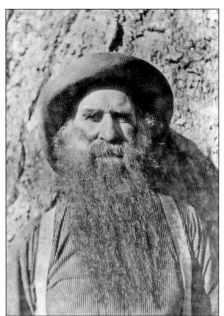

OLD MAN DOANE. Another early bachelor was George Doane, who was rumored to have once been voted "the handsomest man in San Diego." Well-educated and quite the romantic, he penned the lines "Though I like doughnuts and clams, Still better I like the school ma'ams!"

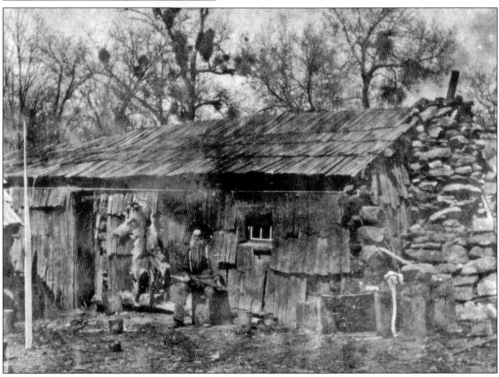

DEFENDING AGAINST ALL ENEMIES. Settling the fertile valley that now bears his name, Doane built this ramshackle cottage around 1890. Having lost valuable livestock to a marauding mountain lion, he and a neighbor ambushed the big cat one night in his darkened corral. Doane quickly caught the cougar by its long tail and swung it around in circles shouting, "Shoot 'em!" For fear of hitting Doane in the dark, no shots were fired and so Doane had no choice but to heave the snarling beast over the stockyard pole fence.

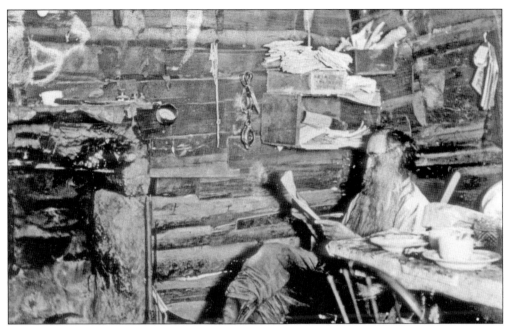

SINGLE WHITE MALE SEEKS COMPANION. Having failed to secure a wife after 20 years on Palomar, George finally advertised nationally for a prospective bride. One response from afar was a woman with a 16-year-old daughter. Impressed, Doane traveled to Louisiana to meet the matrimonial candidate, whereupon he chose to marry the daughter instead. All three returned to his rustic mountaintop ranch to set up housekeeping.

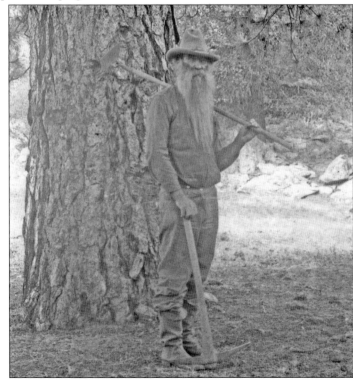

TROUBLE IN PARADISE. Apparently all was not roses as Mr. and Mrs. Doane settled into married life on the mountain. The young bride dyed her husband's gray beard with shoeblack, leaving a telltale coloring on his white shirts and making him a target for local wags. Clearly unsettled, the family eventually moved off the mountain where the May–December romance is said to have soon ended.

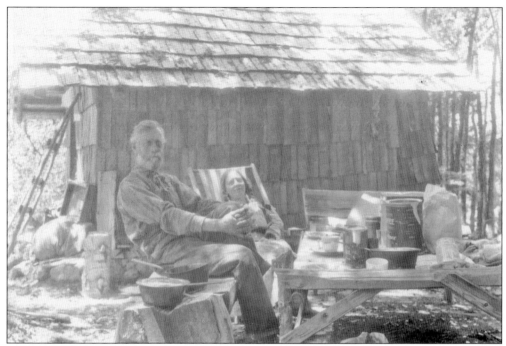

A Different Drummer. Here in a quiet moment at his self-made Spruce Hill Camp in 1910, Robert Asher, known as a "different sort of fellow," was responsible for much of the anecdotes and images of early Palomar Mountain. Largely on his own, he spent the better part of five decades wandering on and around the mountain.

Asher Estates. Still very active on the Palomar scene in the 1930s, Asher created a small, yet unique village around his place above Pauma Creek. This weathered shed dripping in vines seemed to invite relaxation, as captured by his glass-plate camera.

OLD MAN CLEAVER. Born around 1830, Cleaver came to California during the Gold Rush years, settling on Palomar in the mid-1880s. A fixture in the community for decades, he lived in a "well ventilated" one-room cabin, tending an apple orchard for fun and profit. Remarkably, in his 70s he planted hundreds of apple trees on the mountain's west end and religiously hand-watered each sapling for years.

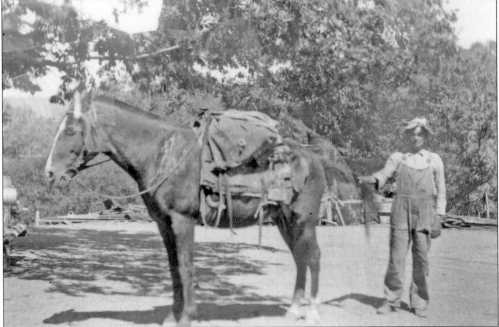

MR. JOLLY. Mail was the lifeblood of most small, isolated backcountry communities. Delivery was twice a week up a trail on the mountain's steep south face. The trek required a climb of almost 3,000 feet from the valley below. Although now frowned upon by the postal service, Jolly solved his transportation problem by loading the mail on horseback, grabbing the animal's tail, and hitching a tow to the top.

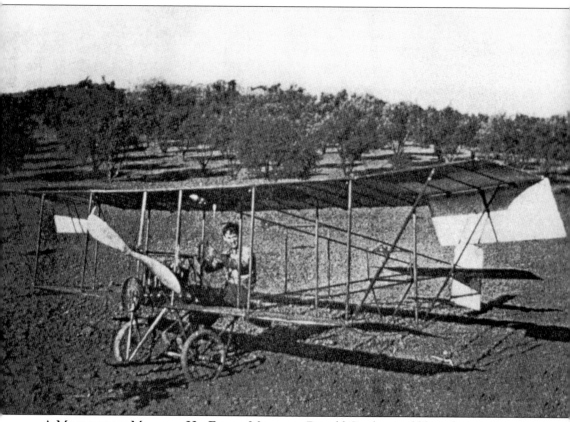

A MAGNIFICENT MAN AND HIS FLYING MACHINE. Donald Gordon could have been typecast as the reclusive, odd genius in a Disney movie. In 1908, he constructed a gasoline-powered airplane of his own design and became the first man to fly west of the Mississippi. Shunning publicity, in his later years the "crazy old inventor" lived alone far from the mountain's beaten paths. Known to be "deaf as a post," Gordon nonetheless continued to tinker in his inventor's hermitage deep within the forest. One anecdote has an approaching visitor being doused with dishwater when arriving at Don's shack. It seems the unsuspecting visitor did not catch Gordon's eye before Don heaved his soapy water load through the open front door. (Courtesy Valley Center History Museum.)

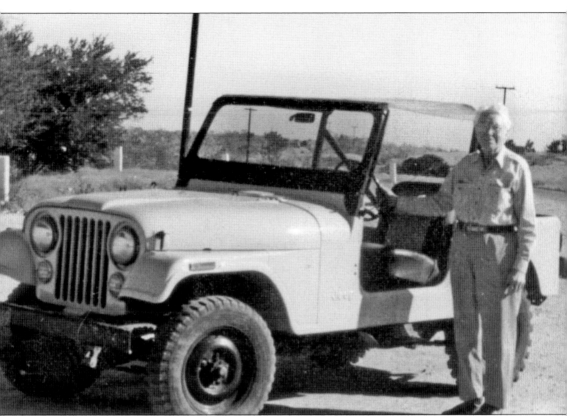

NEVER BETTER. Leonidas Hannibal Anderson (shown here with his trusty jeep around 1970) was both reclusive and exceedingly personable. Born in the Midwest in 1910, "Andy," by the age of 67, had retired to his little cabin on Palomar. He rode his bicycle every morning before dawn until he hit an obstacle in the dark, flipped the bike, and broke his neck. Upon returning from the hospital, he was bound with a Sputnik-like neck brace and headgear. When asked how he felt after his fall, his reply was, as always, a hardy, "Never better!" With that, he would slip on his backpack, buckle up cross-country skis, and trudge off to his cabin over a snow-covered trail. Andy lived to celebrate his 97th birthday and a lively half century on the mountain. (Courtesy John Anderson.)

JUST HARD TO FIND. The quintessence of solitary self-sufficiency could be found in the persona of Gustav "Gus" Webber. Emigrating from his native Switzerland in the early years of the 20th century, he first came to the mountain in 1921. Alpine sensibility was no doubt a factor in his ability to eventually carve out a 240-acre ranch for himself behind seven locked gates on the foreboding north ridge of Palomar Mountain.

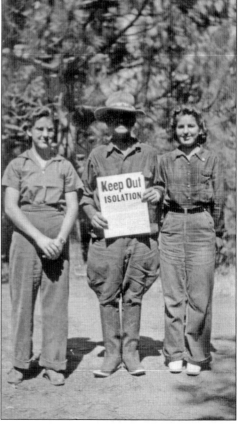

NONE SHALL PASS. A jack-of-all-trades, Gus applied an old-country work ethic to his every endeavor, which included ranch manager, U.S. forester, and in 1937, head groundsman for California Institute of Technology's newly commissioned Palomar Observatory construction project. A hard-working taskmaster, he nonetheless was known as a job-site practical joker in a way that characterized the workingman's spirit during the Great Depression.

MIRROR IMAGE. Grizzled by years of hard labor, Gus (right) nonetheless was revered and respected by all. Taking a break from outdoor duties, he was invited to pose while suspended inches above the delicate 200-inch telescope mirror in this 1964 photo op. Gus worked closely with the telescope construction crews throughout the observatory project.

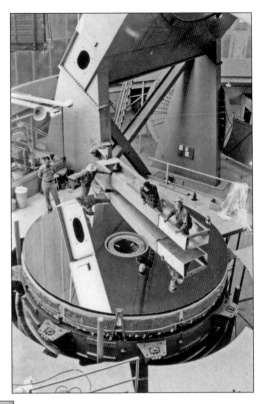

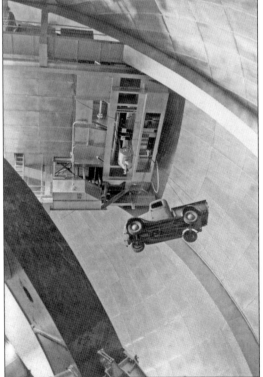

WHEN GOOD PRANKS GO BAD. While running a brush-cutting crew during telescope construction in the 1930s, Gus killed dozens of rattlesnakes. In a quick-witted stroke of inspiration, he once coiled a warm, but headless viper upon the crane operator's seat during lunch. Recovering from a near heart attack after sitting on the bloody reptile, the crane operator then plucked Gus's truck from the ground floor and placed it into the overhead where it remained hidden for hours in the 200-inch dome.

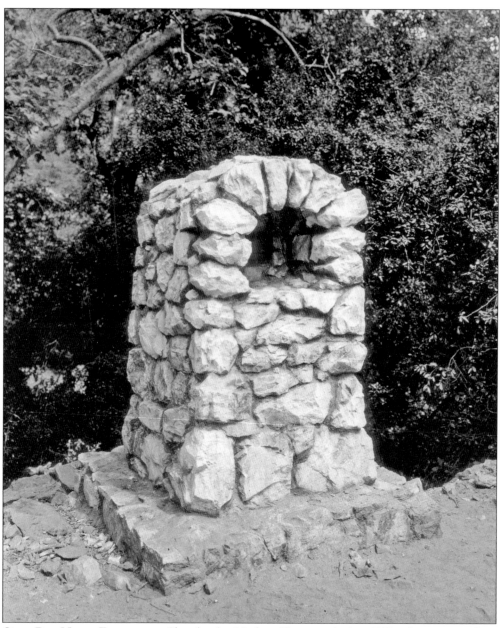

GONE BUT NEVER FORGOTTEN. Shortly after Nathan Harrison died in 1920, admiring members of the Palomar community erected a stone pillar in his memory. It stands today near the site of his old hovel along the narrow, steep, and rocky roadbed that bears his name. Twice cast and twice stolen, a brass plaque within the small stone vestibule originally quoted the poet Burns, "Nathan Harrison's Spring / Brought here a slave about 1848 / Died Oct. 10, 1920 / Aged 101 years / A man's a man for a'that."

Five

FIRE AND RESCUE ON THE MOUNTAIN

"The first time we evacuated, we even took everything including the piano. These days we keep a few boxes by the door ready to go at the drop of a pie pan," so says a four-decade veteran of Palomar's annual wildland fire season, which can run from July through October. Another longtime inhabitant vows to grab only the three "p's"—papers, pistols, and prescriptions.

By any measure, wildland fire is a hazardous fact of life in the western United States, yet the mountain tradition of self-reliance is reflected in the studied response to environmental catastrophes by most of the locals. One early and prominent resident saved the day in the mid-1930s in a fashion that would have resulted in mandated jail time today.

A raging fire was quickly ascending the mountain's south face from the valley below. With no assistance promised or available, he loaded his two school-aged boys into the ranch truck and drove along the rim of the mountain instructing his youngsters to set the downhill brush ablaze as they drove. The resulting backfire prevented the wild fire from jumping East Grade Road and probably saved the Birch Hill area of the mountain. When the flames died down, this good samaritan was summarily called before a federal magistrate and accused by the government of reckless endangerment, a very serious crime. "Well, did the backfire stop the blaze?" questioned the judge. "Yes, your honor," answered the federal man. "Then case dismissed!" snapped the judge and the accused walked free.

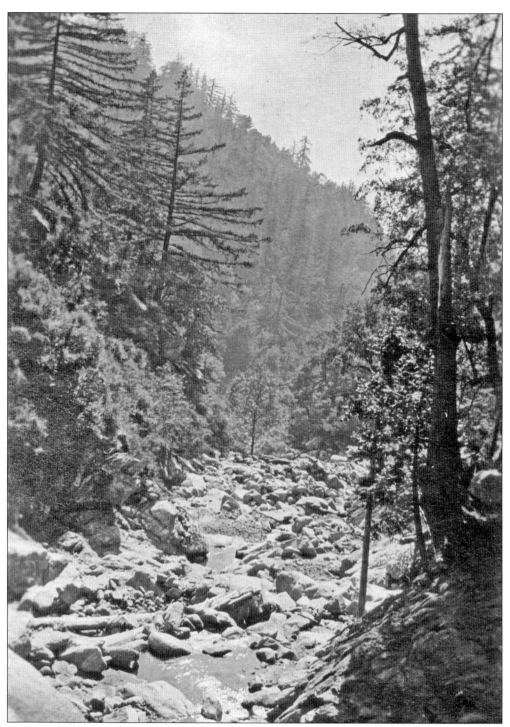

A BAD REPUTATION. "The odd thing about Palomar is that [any given rescue] results in either a Band-Aid or a body bag." This blunt assessment has been shared by generations of rescue personnel and refers to the potential hazards of Palomar Mountain. Here a section of the infamous Pauma Creek, midway down the 3,000-foot descent, is captured during low water in late 1893.

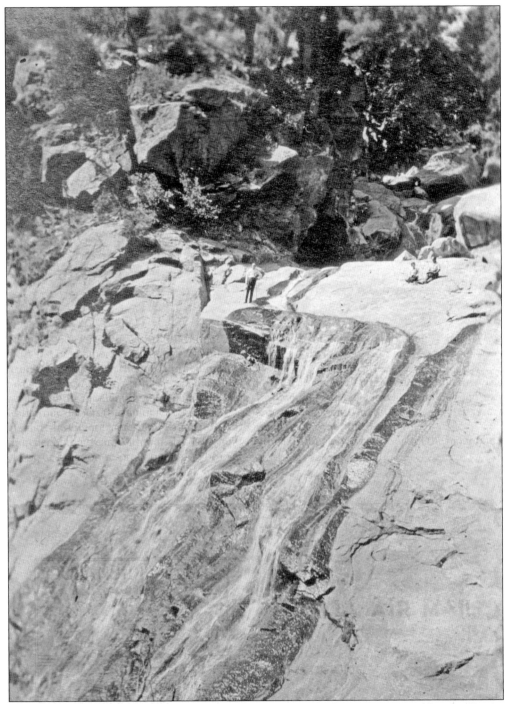

NOT JUST A CLEVER NAME. From its earliest recorded history, the mountain's wild and seductive terrain has both lured and intimidated travelers. Slide Falls's polished surface, dwarfing this gentleman hiker, slopes insidiously downward. Tempting the unwary with a magnificent view, this finely burnished granite surface is lightly dusted with dried moss and has proven to be unstable and often fatal.

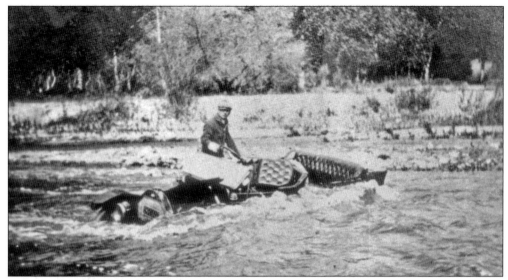

SWAMPED. No less foreboding is the unpredictable San Luis Rey River. Named for the old Spanish mission 30 miles down the valley. An unidentified sadder-but-wiser traveler around 1915 abandons plans for a Palomar vacation, and instead ponders escape from the torrent.

OVER THE SIDE. Having successfully braved the river crossing, the one-lane Nate Harrison grade offered travelers another challenge to both man and machine. With primitive mechanical breaks, vacuum fuel pumps, and straight-cut gears, many early automobiles were woefully inadequate for the challenge. Having plunged over the side around 1915, the open top of this car facilitated a quick exit by passengers and driver alike.

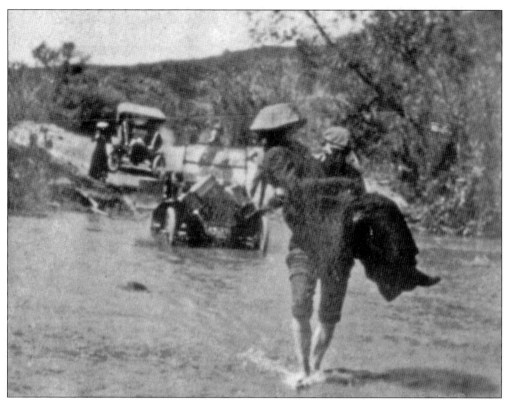

FORDING THE SAN LUIS REY. Chivalry prevails as this gallant coachman gracefully ferries his lady passenger across the running brook. With open ignition systems, no batteries or an electric starter, horseless carriages of the time often succumbed to the native elements.

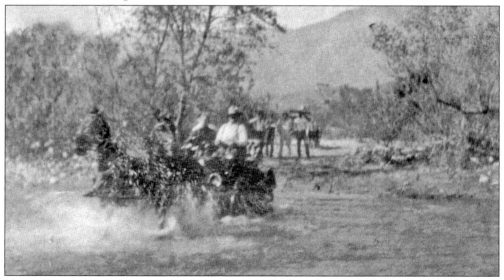

HORSE POWER. With the mountain looming in the background, the Palomar Stage fords ahead, as a preemptive measure, under a lively two-horsepower. Due to frequently improvised situations such as this, early automobile travel to and from the mountain could be thrilling even to the seasoned and hardy vacation traveler.

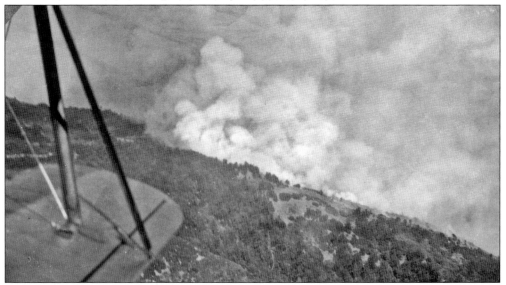

ON THE WING. This 1934 birdman's view captures one of many Palomar wildland fires from the open cockpit of a Forest Service contract biplane. The frailty of these early fabric-covered machines meant air support was reserved for observation purposes only. The type of aerial fire suppression known today was not in use until the late 1940s. (USFS.)

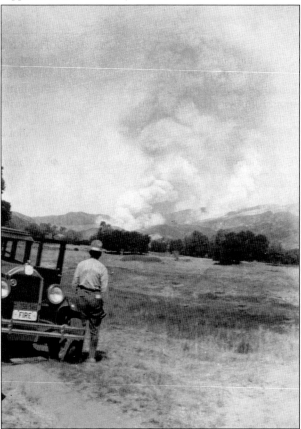

THE BIG ONE. Empathizing with this lone observer, those who have lived with the threat of wildland fire all share the foreboding that comes from viewing a cumulus of destruction. This 1928 fire passed just north of the mountain, destroying the U.S. Forest Service fire station at Oak Grove. (USFS.)

A Cry for Help.

Seemingly quaint by today's standards, the author of this 1910 government interoffice request for funding masks his sense of urgency in a succinct, professional letter. Occurring two decades prior to construction of the observatory, Palomar was nonetheless deemed worthy of unlimited fire suppression efforts. (USFS.)

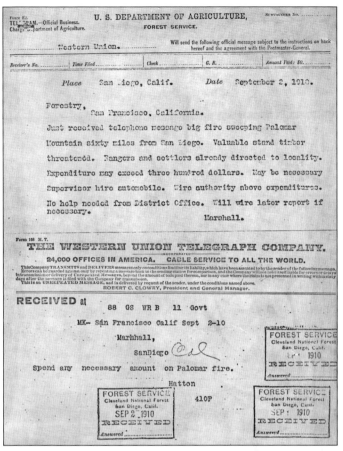

BACK FIRE. Before the day of government-funded aerial fire suppression, wildfires on Palomar were fought by hearty local residents wielding wet gunnysacks to beat back the flames. Men and boys worked the line while women ferried food and supplies to the front. By 1932, professionally directed backfires (above) became a valuable tool for fire-scene management. (USFS.)

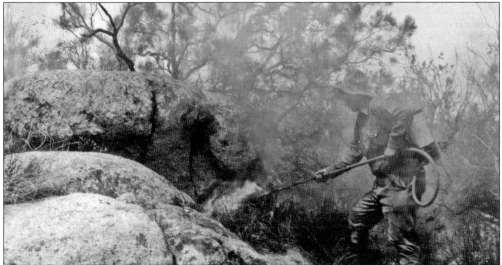

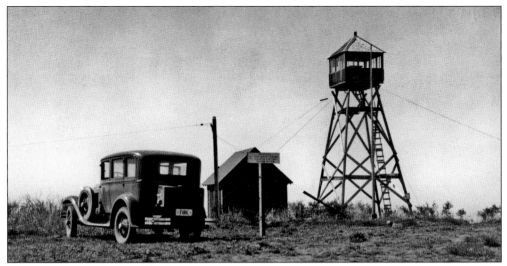

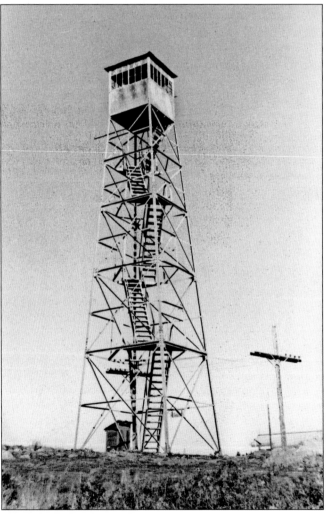

LOOK OUT! By the 1930s, government fire-service spotters bracketed the mountain north to south. The original Boucher Hill tower anchored by guy wires (above) seems but a glorified water tank and must have raised eyebrows during a strong blow. Boucher Hill commands an astonishing view to the south, covering the mountain and lowland valleys stretching out to the Pacific Ocean. To the north, stands High Point lookout tower (left), built in 1935 as part of an 11-station sighting network. Rising the better part of 100 feet above the lonely 6,140-foot summit of Palomar, the all-metal High Point also acts as a first responder to lighting storms rolling over the mountain. Smoke sightings reported via radio by these seasonally manned outposts provided for a rapid response to wildland fires. (Both, USFS.)

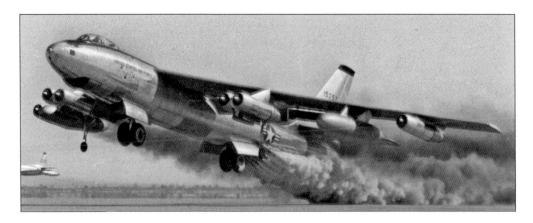

PLANE CRASH. With belching flames and screaming rockets, a Boeing B47 (above) seems the very harbinger of the thermonuclear holocaust it carried in its belly during the cold war years. On December 18, 1957, bound for March Air Reserve Base, while flying through thick cloud cover, a descending B47 met the ascending slope of mile-high Palomar Mountain. The crash killed all three crew members as the bomber skidded directly into Palomar Observatory's utility compound (below), where the superintendent's horse was the only ground causality. Although no photographs where released, it has been suggested that the Strategic Air Command (SAC) aircraft had nuclear weapons aboard. Many aircraft have ended their final flights on the mountain, and some remain hidden in the rugged canyons and thick forests to this day.

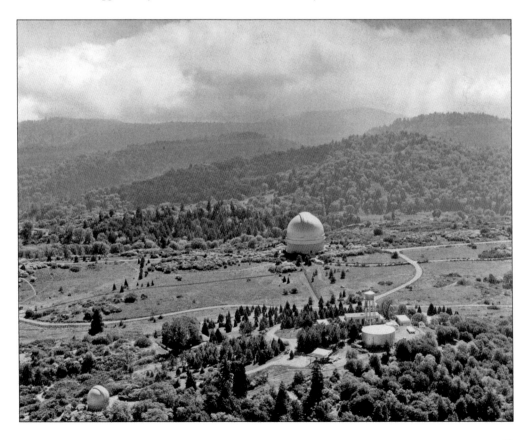

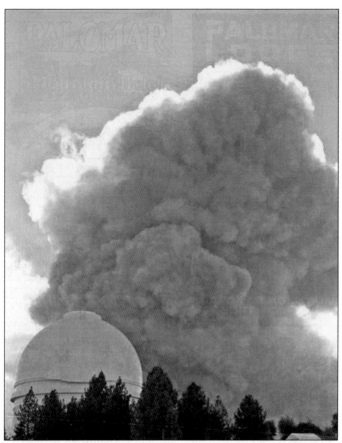

FIRE STORM. Billows of unbridled smoke dwarf Palomar's 200-inch telescope dome during the 1997 cedar fire (left). In fact, the smoke cloud had ascended the mountain's south face a full 6 miles away. Having writhed upward over the near-vertical forest canopy, flames erupting at the crest were five times the height of the 120-foot tree line. This night shot (below) conceals the concentrated heat generated through the uncontrolled incineration of Palomar's mixed hardwoods and conifers. Wildland fire progress slows considerably within forest environments, but the challenges of suppression are increased manyfold by the rugged terrain and seemingly endless dry fuels feeding the insatiable fiery torrent. (Both, CGL.)

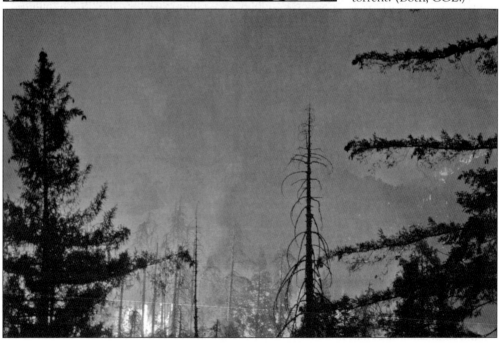

AIR SUPPORT. Dead on target, this airdrop gave the photographer mere seconds to seek protection from the welcomed airborne onslaught of liquid retardant that quickly contained a small brush fire on Palomar around 1976. Unfortunately, aircraft are restricted from flying at night or in the high winds and steep canyons that bedevil the mountain. Frontline efforts fall to these foot soldiers in the war on wildland fire, shown below in the 1997 cedar fire. Although forest fires tend to "lie down" somewhat at night, flare-ups are common and can be lethal. Often suppression personnel remain continually on duty, taking only brief catnaps during an incident that may last for weeks. (Right, Harry Schrader; below CGL.)

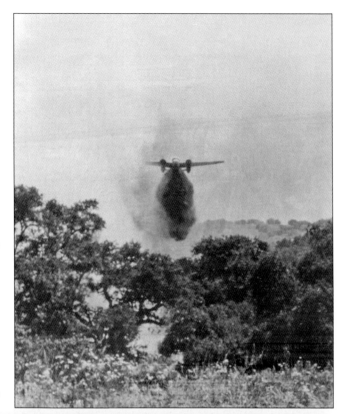

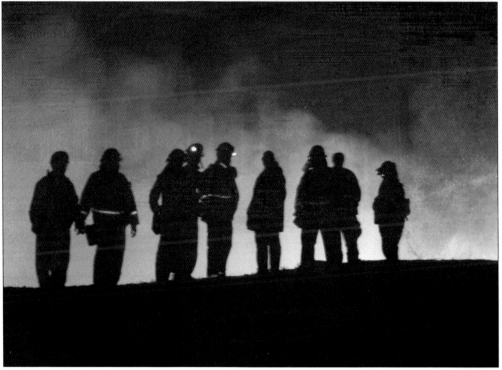

FUTURE FIREFIGHTERS OF AMERICA. Esprit de corps comes easily to this hearty young band of Palomar's finest, posed here on the chief's vintage engine. The community of Palomar Mountain supports an excellent volunteer fire and EMS service staffed by local residents year-round. The mountain is also home to a federal U.S. Forest Service engine company. State CAL FIRE and reservation departments are stationed near the base of the mountain. (CGL.)

Six

GLASS, CELLULOID, AND HAPPENSTANCE

This is a book of images, which at a minimum is intended to provide the reader with a glimpse of the times. A well-composed picture can provide insight into a larger story with content alone or assisted by a few words to bring the event into focus. The following images have a common thread in that they were all premeditated; that is, they were designed to be more than mere candid snapshots. Not all are the results of studied professional practice, but each provides a worthy and lasting record where once there was none.

In the late 1800s, camera equipment transported up the steep mountain grades was bulky, fragile, and fraught with difficulty, and the resulting pictures seemed posed and rigid. The first decades of the 20th century brought with them George Eastman's all-American wonder—the point, shoot, and mail-in box camera containing rolled celluloid film. With this innovation, pictures became more frequent, spontaneous, and in the Palomar collections, certainly more whimsical.

Many professional photographers have created striking images, some per the directives and diligences of government service, and others from the necessities of scientific study. Commercial photography on and of Palomar is represented here in singular frames and movie stills, some silent and others clearly outspoken.

Finally, images for the sake of artistic expression can reveal a depth and latent purpose among the forgotten remnants of times past. Below is a sampling, from the earliest glass-plate photographs to modern digital media, that brackets Palomar's unique and pristine environment and provides a window into the elusive spirit through the photographer's studied eye.

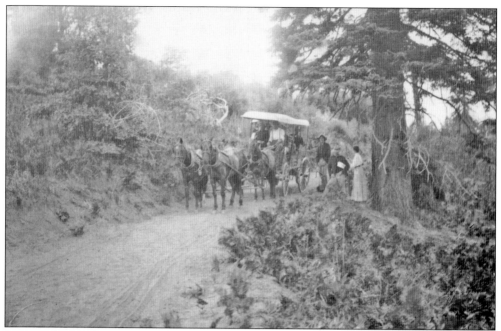

LEMON LILIES ON GLASS. "Oh, it's only Bobby Asher." This often-heard phrase seemed to follow Robert Asher and his 5-by-7-inch plate camera as he meandered about the mountain shooting objects and persons of interest as the mood would strike him. He was around Palomar for most of his 85 years. He earned a modest living through the harvest of rare mountain flora and sale of his photographs of the early days. Above he captures the weekly Palomar Stage at Lone Pine in route to Palomar Resort around 1910. Below a wagon driver has just entered the tree line at the 4,000-foot level above Nate's place.

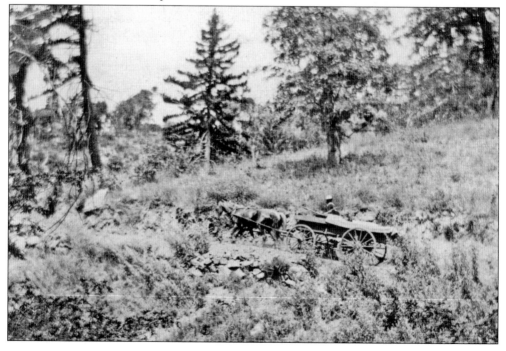

ANYTHING YOU SAY, C. B. Above a desperado takes his queue from famed Hollywood movie director Cecil B. DeMille. While shooting *The Virginian* on Palomar in 1914, the director, cast, and crew were the subjects of local fans armed with Eastman's latest Brownie Box camera. Below, actor Dustin Farnum, in white face paint, silently reveals yet another plot device. A few notable films have been produced on the mountain including the 1977 sci-fi classic *The Crater Lake Monster*, filmed at Doane's Pond and *The Cabin in the Woods* (2010), coming soon to a theater near you.

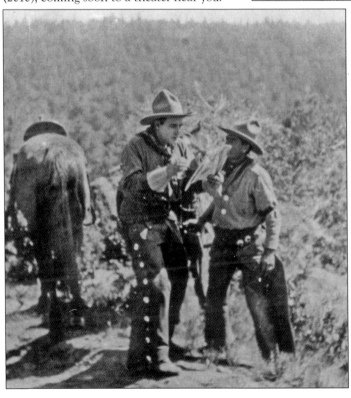

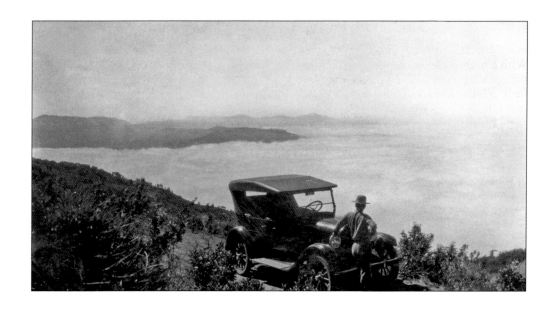

GOVERNMENT JOB. For over a century, the U.S. Department of Agriculture has administered almost half a million acres of land in Southern California. Known collectively as the Cleveland National Forest, much of Palomar Mountain is under the stewardship of the U.S. Forest Service. The mountain has benefited greatly from the agency's land-management policies and the reservoir of images captured when backcountry infrastructure was in its infancy. Above, this 1923 view off Palomar's southern face seems reminiscent of a coastline. Forested mountaintops protrude from a sea of dense costal fog, common in the spring. Below, Doane's cabin is a rare and wonderful holdover from the late 1800s. At the time of this 1920 photograph, Doane and his family had departed the mountain leaving the log cabin to slowly fold back into the rich soil. (USFS.)

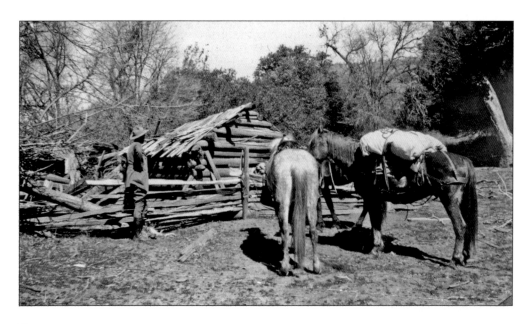

HAVE CAMERA, WILL TRAVEL.
With a trained eye and armed
with cans of unexposed 2-by-2-
inch celluloid film, the owner
of this little runabout pauses
while on assignment atop
Palomar Mountain. Hired by
the proprietor of a local resort,
and with the mission to provide
professional-grade photographs,
the unnamed photographer
created a lasting portfolio, one
snapshot at a time. Right, a
typical one-lane country road
opens into the Dyche valley.
Below, the last original tepee
on the mountain stands quietly
for the requisite portrait. Today
dispersed across the land and
separated by generations, many
of these remarkable images
have found their ways back to
the mountain from within attic
boxes and top desk drawers,
long forgotten until now.

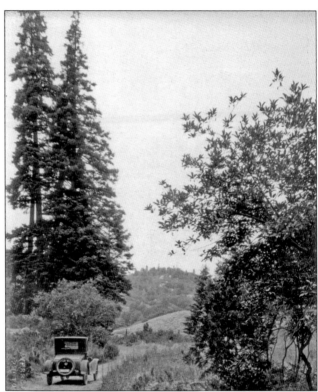

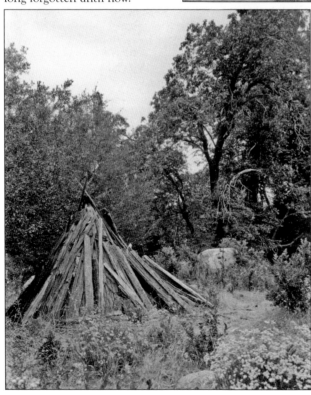

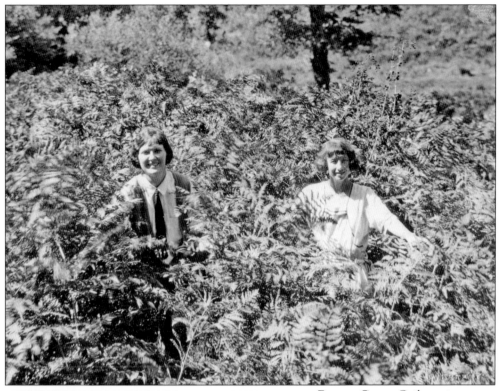

POSTER GIRLS. Gaily posing for the camera, visitors smile while all but engulfed by giant bracken fern sometime in the mid-1920s. Visitors to arid Southern California routinely delight in discovering forests of mixed oaks and cedar atop the mountain. Lush valleys on Palomar, similar to those of New England, provide a welcomed respite for the eastern traveler. A covered natural spring at Bailey's provides refreshment from the handy tin cup shared by all. Sourced from the deep subterranean Cold Spring aquifer, the water temperature remains remarkably cool over the summer months.

OF FIELD AND STREAM. Iron Springs Creek (right in the mid-1920s) is stocked with trout for the season by this band of foresters. At right, in the rear of the photograph is a young Gus Weber. As a German-speaking immigrant from Switzerland, Gus originally came to Palomar Mountain, so the story goes, by way of back roads traveled to avoid immigration issues during the time of the Great War. Note the period fedora headgear and leather gaiters above the boot. These were worn as protection against a certain poisonous reptile that seems to enjoy the cool rocky areas found around springs and creeks. Below, a rustic two-bedroom cabin popular during the period, constructed of native stone and slab siding from a local sawmill.

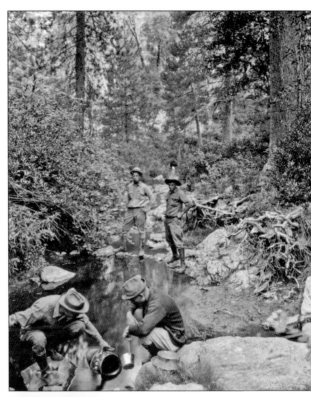

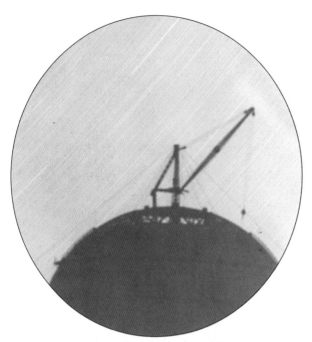

STARTLING DISCOVERY. Captured by Palomar Observatory's largest telescope at the time, the rare 1930s image above has remained unpublished until now. The circular film clearly shows faint star tracks behind a spherical foreground object with spinally appendages, clearly of intelligent design. The telescope, known as the 18-inch Schmidt Camera, exposed a small disk of emulsion-coated plastic that was preloaded into the telescope tube. The image was captured when a shutter opened on the tube's far end, briefly exposing the optical train to the night sky. The first of the large instruments constructed on Palomar, the Schmidt Camera (right) continues to search for comets and asteroids, helping to map objects that may impact the earth. Unlike the stuff of outer space, however, this gin-pole crane atop the uncompleted 200-inch dome measures but a mere half mile distant. (CIT.)

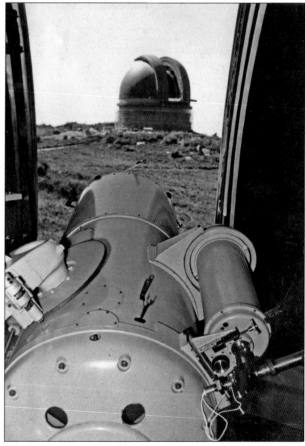

76

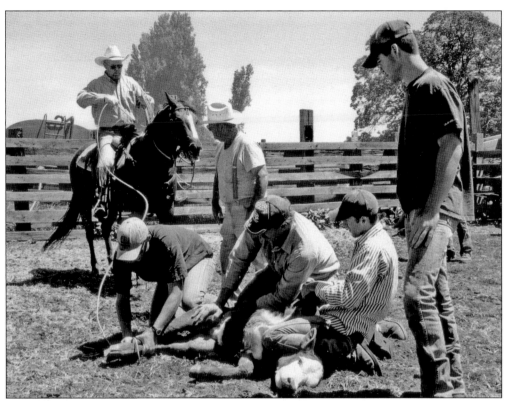

HOLD IT RIGHT THERE. Briefly captured by this team of wildlife specialists, a native bovine submits to temporary immobility prior to being tagged and released back into the wild. An annual event on the Palomar Land and Cattle Company's family ranch, badly needed manpower is often supplied by fit and willing volunteers, one of whom has captured the moment in digital media (above). Suitable for framing, this image of an antique triple combination pumper provides foreground content against the backdrop of Bailey's Dance Hall (below). Palomar Mountain Volunteer Fire Department embraces this tried-and-true emergency response vehicle as both mascot and rolling promotion. (Above, CHB; below, CGL.)

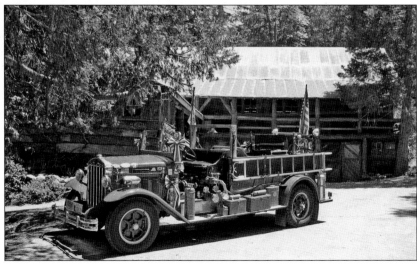

EYE OF THE BEHOLDER. Above, the century-old Palomar General Store looks sadly "a little long in the tooth" as captured by this mid-1990s snapshot. For decades, it was the center of the Palomar Mountain community and the former home of the Nellie Post Office, but by this late date its signs of wear and neglect would seem to question its prospects for longevity. Yet a certain well-worn, rustic aesthetic emerged as the photographer directed both lens and talent toward the small porch, left. (Courtesy Jack Jennings.)

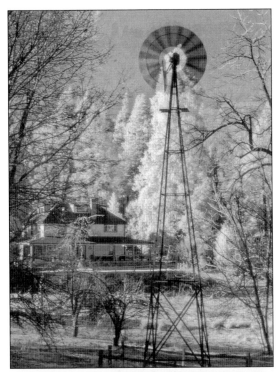

AVANT-GARDE. Photographers visiting Palomar often dive into a wellspring of imagery and icons from the past. Applying advanced photographic techniques with award-winning results, Chuck Beishline's windmill disk (right) softly blurs before a seemly frosted forest in this daytime infrared exposure. Venerable *Big Red*, a 1947 GMC pickup put out to pasture after decades of hard service on Palomar, now sits for yet another still-life portrait. Edges softened, this hand-manipulated Polaroid transfer technique has become exceedingly rare, as the specialized film required is no longer readily available. (Right, Gary Pang; below, Donna Cosentino.)

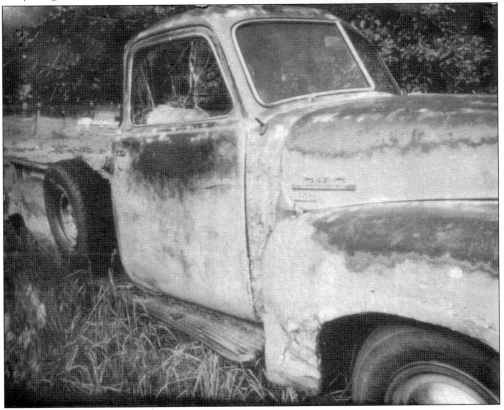

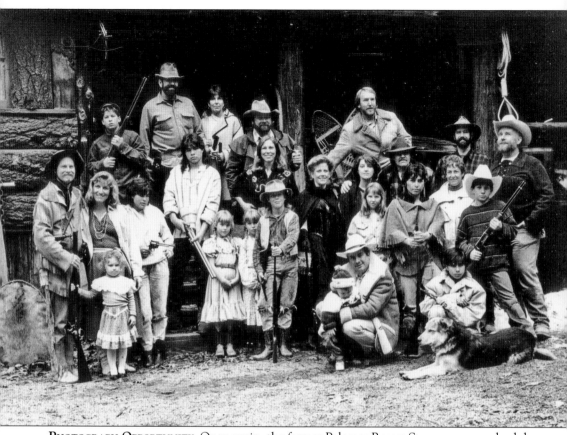

PHOTOGRAPH OPPORTUNITY. Once again, the former Palomar Resort Store serves as a backdrop for this gathering of friends and family around 1990. Sporting period costumes, firearms, and friendship, the photography shoot was planned weeks in advance and followed by a potluck dinner in the former hotel. Donating his time and 5-by-7-inch wooden plate camera, complete with tripod and black focusing hood, Dennis Baugh (far right) assumes a wistful stance reminiscent of Mathew Brady over a century earlier. After the camera had been triggered remotely by a hidden string, the group then adjourned to the table while thanking the photographer for his efforts. Ever the gracious and helpful neighbor, Dennis acknowledged with his signature, "It's the world's biggest no-big-deal."

Seven

POSTED NOTES

People respond at various levels to images and memorabilia. Fundamentally, capturing the moment with a snapshot seems to have a universal appeal to everyone with access to a camera.

Further up the scale, destination adventurers—whether they choose to relax or become inspired—strive to take a piece of their experiences home at their journey's end. Picture postcards serve as personal souvenirs or gifts to that special someone, with a wish that they were there, too. Climbing higher still, if a place attains a certain level of fame, and especially if a place evokes something deemed worthy, it may become fashionable to affiliate the place's name with a certain quality or excellence.

Palomar Mountain has always provided with a remarkable environment and a sense of personal opportunity. Initially that thought was held by the relative few who had ventured onto the mountain. During the 1920s, the selection of Palomar as home for the mammoth Hale telescope project changed forever the impression others had of the mountain. As the grandest scientific endeavor of that time, the name Palomar was seen at once as high of purpose, rich in promise, and the acme of technical majesty.

Seemingly overnight, Palomar became a household name, used frequently in the media prior to the Second World War. Most Americans of that era remember the grand expectations that were eventually realized as the famous telescope began to produce spectacular images from deep space. The following is a small sampling of picture postcards, collectables, memorabilia, and other oddities that all have Palomar in common.

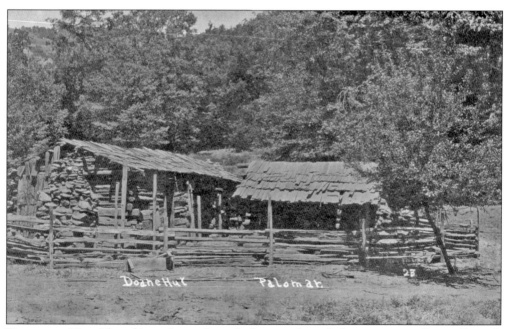

PAY AND BE COUNTED. Originally the word "poll" meant "per-head" as applied to taxes due from an individual by virtue of his residence in a district. This 19th-century receipt for the weighty sum of $2 was paid by Nathan Harrison, a former black slave and the self-proclaimed "first white man on the mountain." Thought to be illiterate, Nate's paperwork was probably completed by another.

DOANE THE HUT. The subject of story, legend, photograph, and silent movie set, George Doane's primitive cabin again surfaces in the historical record, here in a postcard from the mid-1920s. Withstanding the elements for a number of years, the venerable structure was removed around the time Doane Valley was annexed for use as Palomar Mountain State Park.

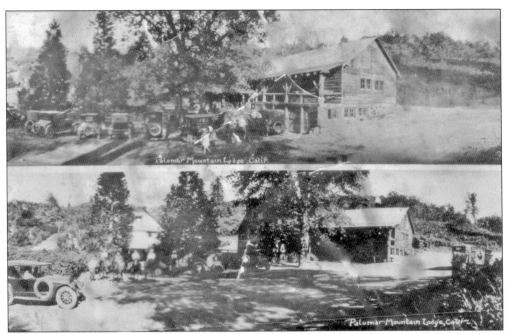

RETURN TO SENDER. The spontaneous generosity of those who submit rare artifacts from the mountain's past is greatly appreciated by archivists. Above is a worn, but serviceable, picture postcard of Palomar Resort dating from the mid-1920s. These gems are frequently discovered lodged under dresser drawers or retrieved from weathered attic boxes, a bit worse for the wear, but nonetheless remarkable.

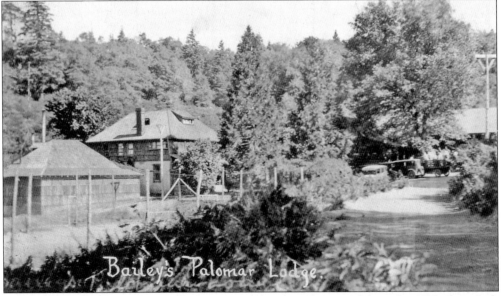

WISH YOU WERE HERE. Shown above is yet another period postcard from the 1920s, here with a refreshingly simple, yet informative, tagline. Soon the wheel of progress would roll up and over Palomar, where such old-fashion promotion would be seen as passé. Yet today, the mountain boasts a simple, uncluttered charm. For the most part, the community has continued to reject attempts at hard-core commerce and the enterprise of exploitation.

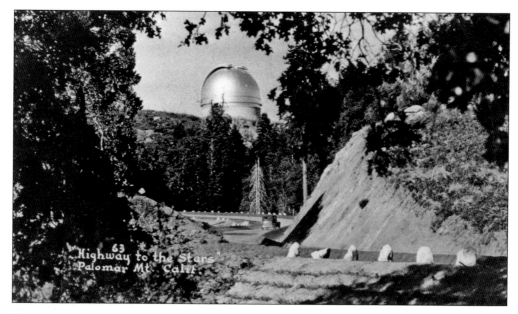

HIGHWAY TO THE STARS. Upon the announcement that the largest, most expensive scientific endeavor ever attempted would reside atop humble Palomar, many doors opened to the possibilities for the mountain. The County of San Diego, envisioning rivers of tourist dollars, offered to sponsor construction of a major thruway from the coastal cities snaking to the top of the mountain. Christened "Highway to the Stars" (below), the journey began at the coastal city of Del Mar and ended 60 miles northeast at the observatory compound (above c. 1936). Although financial grants for the project required the observatory be open to the public, the stoic managers of the telescope project failed to mention that visiting hours would be only during the day. In fact, the huge instrument was intended for use at night by a small fraternity of scientists. (USFS.)

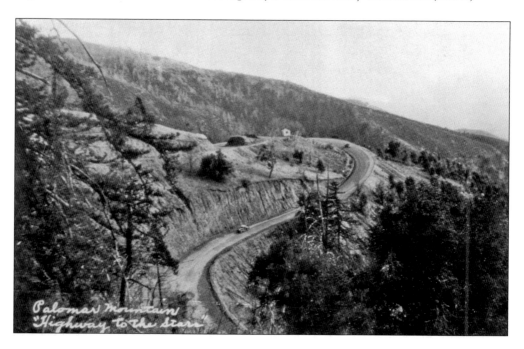

ONWARD TO THE CATHEDRAL OF SCIENCE. At right, this rare image is of perhaps the last of a dozen milestone placards that stood sentinel along the famed 60-mile motor highway of scientific achievement. Posted upon completion of the famous county roadway, and set up at intervals in the mid 1930s, these white-on-black enameled signs graced each proud township along the route. Over the decades, destruction and vandalism slowly thinned their ranks and this bullet-holed specimen may have been the last to vanish sometime during the late 1960s. The quintessence of mechanical majesty and scientific intellect, the newly completed Palomar Observatory dome is pictured below shortly after completion around 1936. This image has served as the model for numerous promotions, from commemorative stamps to food product labels.

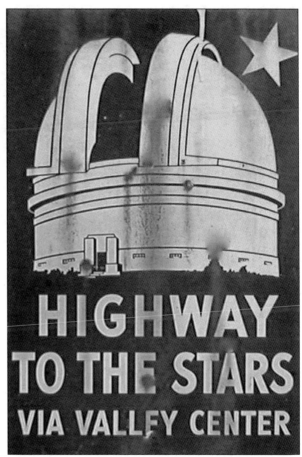

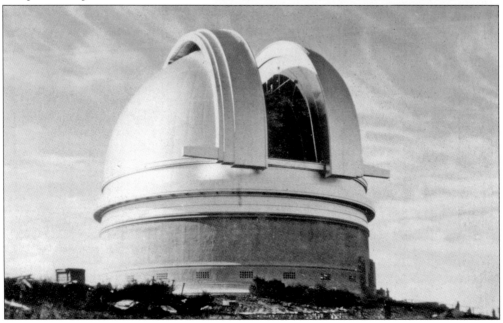

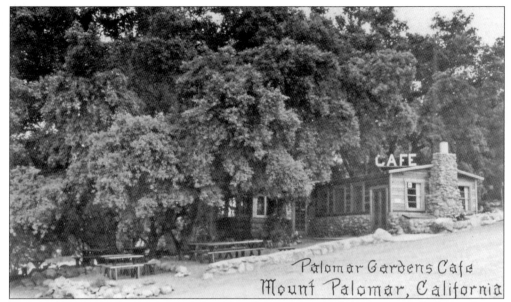

PALOMAR GARDENS. George Adamski, perhaps the most famous former citizen of Palomar, began his international career by founding the Royal Order of Tibet, teaching what he called Universal Law theology from a small eatery and campground, shown here on a postcard from around 1950. Interest in the world's leading observatory just up the road led indirectly to his close encounter with visitors from another world, and his book *Inside the Spaceships*. (GAF.)

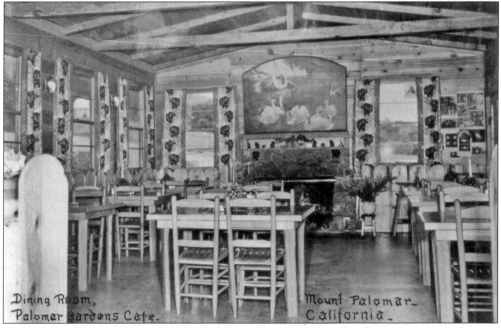

WHAT'S IN A NAME? When this photograph was taken, Professor Adamski was in growing demand by flying-saucer enthusiasts worldwide. Apparently not dissuaded by details, this postcard of his cafe incorrectly states "Mount Palomar" when in fact the place name has always been Palomar Mountain. This not-so-insignificant mistake could result in a tersely worded correction from the mountain's postal service and concerned citizens alike. (GAF.)

THOMPSON'S SUMMIT GROVE. With the completion of the modern "Highway to the Stars," the new roadway afforded a picturesque, if unnerving drive up the exceedingly steep former mail horse trail. In the late 1950s, the center of the Palomar community moved from Baileys to the confluence of the two highways on the mountain called "the summit." This unusual 1948 linen postcard (above) depicts Wayne and Shirley Thompson's crossroads establishment. For 25 years, the Summit Grove offered sustenance, Union 76 gasoline, and a temporary respite for the weary mountain traveler. Below, Thompson's drop-in visitors enjoy clement weather in 1950. Former postmistress Shirley Thompson first journeyed to Palomar on bicycle from San Diego. Finding it refreshing, similar to her native Minnesota, her first years on the mountain began without telephone service, although the mail came at least twice a week.

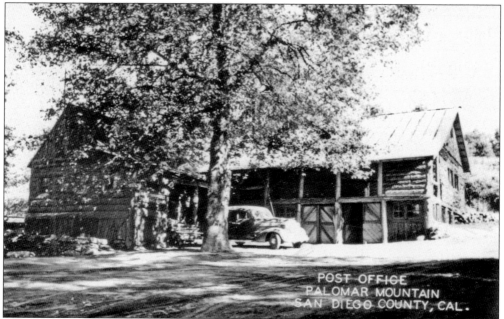

PALOMAR POST OFFICE, 1942. Still in business after six decades, Baileys provided mail services to the small community, which then included the institutions of Palomar State Park and Palomar Observatory. In the winter of 1949–1950, a series of freak snowstorms paralyzed the mountain under a six-foot snowfall. Mail service was suspended for three weeks as postmistress Adalind Bailey weathered the conditions with the supplies at hand.

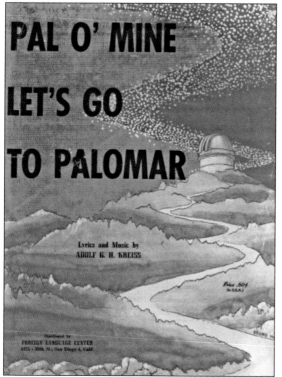

OF SONG AND STORY. This is one of hundreds of published tributes to Palomar Mountain. In this 1962 sleeper, an inspired bard seeks romance from high atop Palomar. This rarely performed love-stuck melody weaves a magical tale of splendor and longing among the stars, ending with the refrain "Pal o' Mine, Let's Go to Pal-O-Mar."

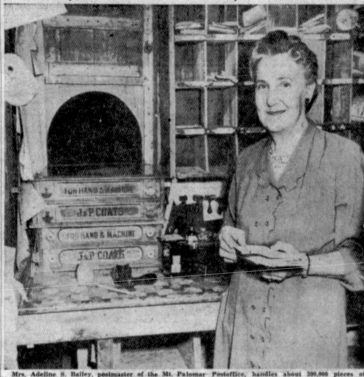

PAGE FOURTEEN—A Sunday Morning—August 29, 1948 THE SAN DIEGO UNION: SUND.

Palomar Stamp Sale to Reach 350,000 Mark

Cubbyhole Postoffice to Be Busy Place Tomorrow

MT. PALOMAR, Aug. 28 (Special)—More than 350,000 letters—nearly twice the tiny Mt. Palomar postoffice's annual business—will carry the Mt. Palomar postmark Monday to every station in the Union and 20 foreign countries.

Most of the mail will be first-day cachets, mailed to stamp collectors with the new commemorative 3-cent Palomar Mountain Observatory stamp.

STAMP DEALERS BUY

A million and a half of the stamps have been sent here by the Postoffice Department, and a third of these will be sold Monday, first day of the commemorative issue. About 150,000 of the stamps have been bought by stamp dealers, according to Robert E. Fellers, superintendent of the Postoffice Department's stamp division. Dealers bought the stamps in lots up to 50,000.

None of the envelopes mailed Monday from the postoffice near the Mt. Palomar Observatory will be empty, although the only value of most of them will be the postmark they bear. Fellers said a Federal law prohibits the mailing of the cachets unless they contain something, even a blank sheet of paper.

EXTRA MEN HIRED

Sixty-five extra employes have been working in a postoffice substation in the Oceanside Community Center preparing the cachets for mailing Monday.

More than 200,000 of the first-

Mrs. Adeline S. Bailey, postmaster of the Mt. Palomar Postoffice, handles about 200,000 pieces of mail a year from this 6- by 4-foot cubbyhole in the general store atop Mt. Palomar, but Monday her postmark will appear on 350,000 pieces of mail. Envelopes will bear the 3-cent Mt. Palomar stamp.

A DAY OF FAME. Heralding the big event, newspapers and radios clamor for angles in covering the dedication of the monumental Palomar Observatory. Decades under construction and eagerly anticipated, hundreds of thousands participated vicariously in the event through the U.S. Postal Service. In the mountain's tiny cubbyhole post office, 62-year-old proprietor Adalind Bailey (above) prepares for the onslaught of stamp aficionados worldwide. At 3¢ each, over $10,000 worth of the commemorative stamps (right) passed through the little office. Taking the week off work in San Diego to assist his mother in her duties, Newt Bailey tells of having a moment of inspiration. By surreptitiously changing a single digit in the cancellation stamp, a simple mistake could produce a priceless collectable. Such an item has yet to surface among collectors, however.

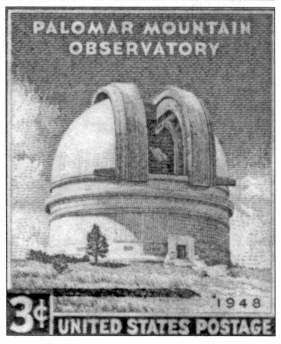

PALOMAR MOUNTAIN OBSERVATORY

1948

3¢ UNITED STATES POSTAGE

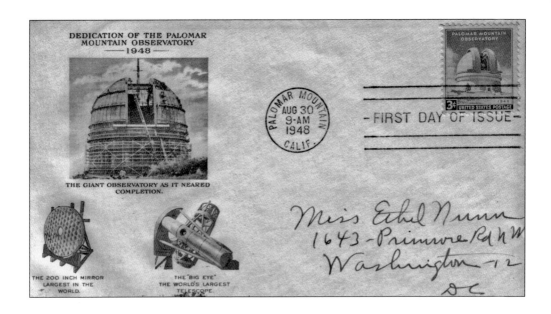

FIRST DAY OF ISSUE. Prized as collectables, these "First Day of Issue" envelopes date from August 30, 1948. Hand-canceled with special attention to appearance, care was taken to preserve the integrity of the stamp while simultaneously maintaining the letter of the law governing postage. Pictorial grade engravings provide a sense of occasion as these illustrations herald the march of scientific progress and the scale of construction. Below, the postmistress authenticates the collectable envelope in flowing Victorian script at the request of the recipient.

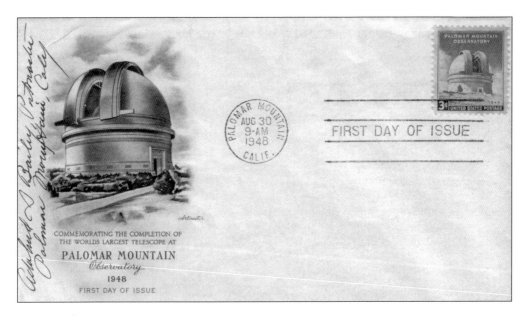

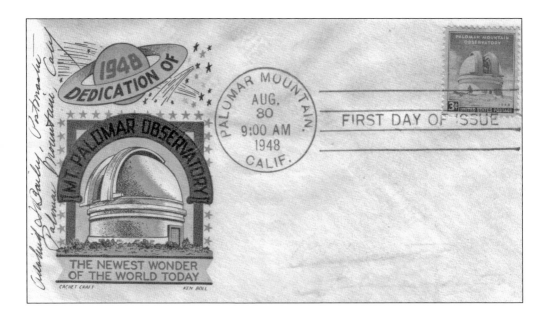

NEXT DAY OF ISSUE. Exceeding a third of a million pieces of mail, the careful hand-cancellation of these commemorative stamps was uniformly dated August 30, 1948. In fact, over a week was required to complete the job. Printed in vibrant primary colors, the collector's envelope above takes on a distinctly futuristic appearance. It was during this period that interest in extraterrestrials began gaining momentum in popular literature. Below, a 1938 airmail envelope from Oceanside, California, depicts the multiple attractions of sun, surf, and proximity to the Palomar Observatory. Despite the Great Depression, Palomar Resort's weekly stage continued to service the Oceanside train depot that year. With war clouds looming on the horizon, however, the age of the mountain's classic destination resorts would soon be over.

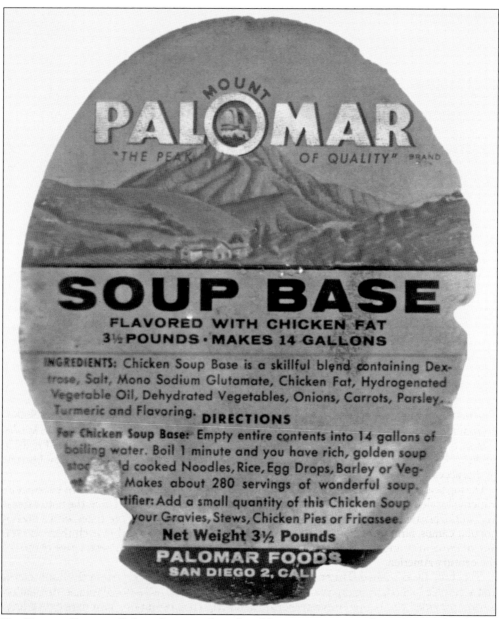

THE PEAK OF QUALITY. Riding the crest of newfound fame, consumer products nationwide adapted the mountain's name as an assurance of quality. Printed in bright circus colors and intended to be discarded after usage, this rare gem is one of many Palomar retro-collectables. Quaint by today's standards, the blatant inaccuracy of the label's name simply adds to the overall charm. As Palomar is a long, rolling geologic upheaval, the mountain contains no obvious single peak and therefore does not qualify as a "mount."

Eight

TRAILS AND TRAVELERS

The first half of the last century was the golden age of destination resorts in the United States. As motorized transportation tempted the adventurous vacationer, many chose to explore locales that only a decade before would have been deemed painfully remote and hazardous. Roadside cookshacks, tin-can camps, and souvenir shops arrived in the newly tamed Southwest because of this accessibility.

During this period, the Yosemite Valley, the Grand Canyon, and other lesser-known-but-equally-enticing locales offered upscale, yet charmingly rustic lodging constructed from the native forest and stone quarried nearby. Palomar Mountain responded to the call of the times with a host of popular camps, farmhouse hostels, and land-office real estate offers. Within each there was the lure of tranquility and the promise of a mountaintop haven, safe from the hectic pace of turn of the century America.

"Fear not," flyers boasted. The once-rugged backcountry had been made safe by the frontiersmen and accessible by modern transportation. Before the advent of the recreational vehicle, destination resorts provided the happy wanderer with round-trip transportation, sustenance, bedding, amusements, and wholesome outdoor recreation, all for a modest fee. Offering accommodations by the day, week, or season, and high above the arid landscape down below, the tourist industry had found Palomar Mountain.

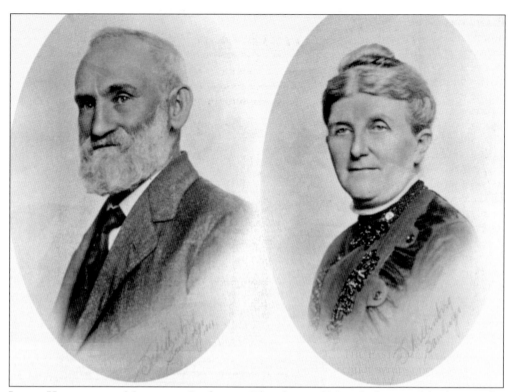

LITTLE HOUSE ON THE MOUNTAIN. By the time Theodore and Mary Bailey posed for these studio photographs in 1920, they had lived on Palomar for 33 years. Migrating from Kentucky in the 1870s, they had homesteaded their little mountain valley and constructed log cabins and an adobe farmhouse by 1888. Over the next three decades, with their six children at home, the family built a farm, post office, general store, barn, and blacksmith shop, and they also developed a summertime resort business atop Palomar. Below, Mary pauses from her chores for this 1890 picture of their adobe, now boasting new attic windows. The venerable old building begins to take the shape of the hotel it will someday become. Note the pair of small cedar trees planted in the front yard, which today measure over 6 feet across and tower some 130 feet overhead.

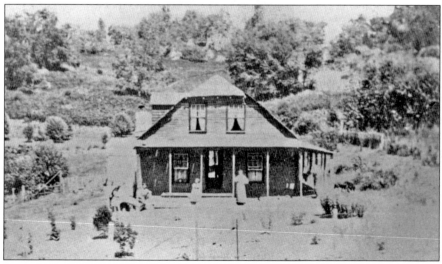

PLANWYDD. Other hostels arose from family farms, such the Robert's Planwydd Hotel. Yet, maintaining a living on the mountain was a continual challenge. Varmints constantly threatened the family gardens and the proprietor's livelihood. Robert's young daughter Elsie recounted in later years being paid 10¢ for every squirrel she killed. For a youngster bringing home bushels of critters, she made a lively income.

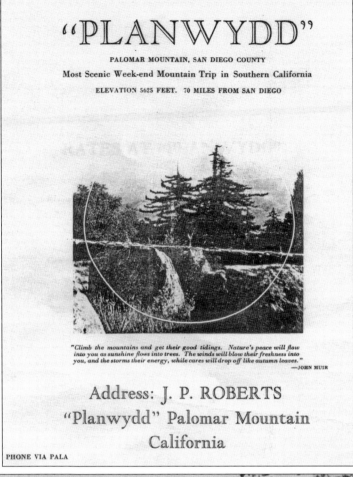

"PLANWYDD"

PALOMAR MOUNTAIN, SAN DIEGO COUNTY

Most Scenic Week-end Mountain Trip in Southern California

ELEVATION 5625 FEET. 70 MILES FROM SAN DIEGO

"Climb the mountains and get their good tidings. Nature's peace will flow into you as sunshine flows into trees. The winds will blow their freshness into you, and the storms their energy, while cares will drop off like autumn leaves."
—JOHN MUIR

Address: J. P. ROBERTS
"Planwydd" Palomar Mountain
California

PHONE VIA PALA

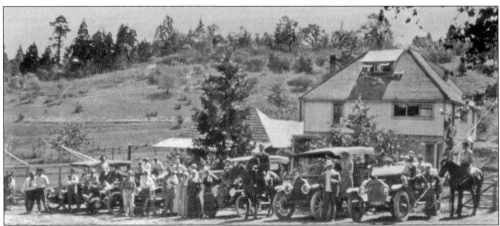

CAMPO CONTENTO. Graduating from the University of Southern California's class of 1913, Dr. Milton Bailey had his family's resort business to thank for his higher education. Boarding in Los Angeles while earning his dental degree, he would run the family resort business with his parents and siblings each summer. He would eventually own and operate the resort over three decades during summer months while on leave from his dental practice in San Diego.

STREETS IN AND PAID FOR. Now a prominent residential community on the mountain, this eastern hilltop was formerly the homestead of the future Lord Harry Birch and his younger brother. The novice pioneers quickly became discouraged with wilderness living, leaving the area their name before departing. Around 1920, the area was subdivided into campsites and marketed out of Los Angles as the National Forest Country Club. Singing the praises of clean mountain air, easy access ("just five hours away"), and private ownership, this brochure offered individuals membership with small campsite lots, in language familiar to land-office promoters everywhere. The central draw to the area was the clubhouse, once called Edgewood Tavern and later Skyline Lodge. The building has had many uses over the decades, including a road construction camp during the 1930s.

CEDAR CREST. At right is one of many motor camps on the mountain during the first few decades of the 20th century. Others boasted folksy names like Ocean Camp, Silver Crest, Big Tin-can, and Little Tin-can. They were mostly the result of hopeful entrepreneurs in search of elusive tourist dollars as more travelers braved the twin hazards of primitive roads and gas-powered conveyances.

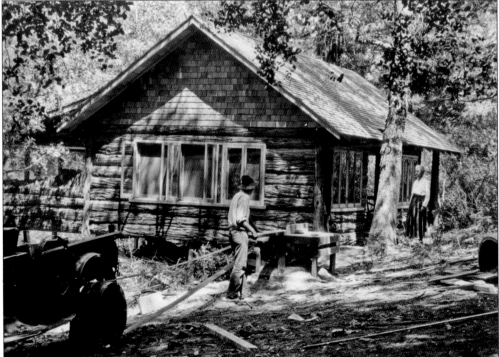

COTTAGE INDUSTRY. A boom, spurred on by local land developers, generated the construction of a host of woodsy log cabins, mostly in the Birch Hill and Bailey subdivisions. In time, these remarkable summer retreats would characterize the architecture on the mountain, although some structures barely stand now, "mostly out of habit." Note the truck-powered flat-belt-driven table saw.

BY ANY OTHER NAME. Here Bailey promotions bracket the resort era, with this turn-of-the-century engraving (left) and the more modern block-style version popular in the 1930s (right). The resort has served travelers continuously for over 125 years under the names Campo Contento, Palomar Hotel, Palomar Lodge, Palomar Resort Company, and Bailey's Palomar Resort.

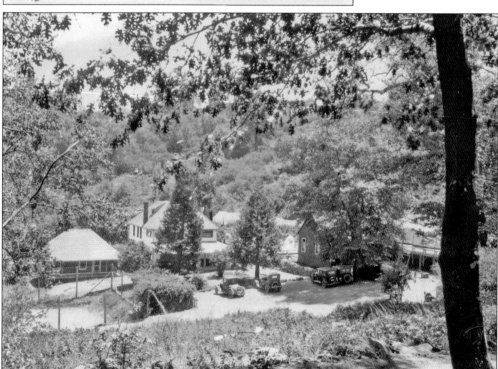

PALOMAR RESORT COMPANY. The resort had been growing for close to two decades in this 1924 photograph. From left to right are the tennis court, dining room, kitchen, hotel, general store, and post office. The new dance hall is under construction. Two tents behind the house were for family youngsters Steve and Newt Bailey, who helped out while the resort was in operation every summer.

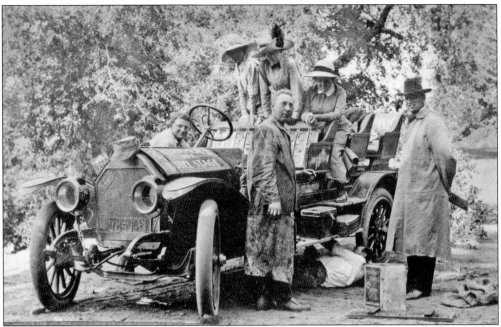

A TALE OF TWO PHOTOGRAPHS. During the summer, the Baileys ran a weekly stage down the mountain to the Oceanside train depot some 35 hard-driven miles each way. This "three-seater" Cadillac was one of the finest and most rugged automobiles of the day. Nonetheless, breakdowns were all too frequent. Above, bonneted but helpful passengers supervise emergency repairs somewhere along the formidable Nate Harrison grade around 1913. Another intrepid band of travelers celebrates the successful accent of mighty Palomar's west grade. Pausing briefly for a memorial photograph before pressing onward, proprietor Dr. Milton Bailey smiles behind the right-hand drive steering wheel, below.

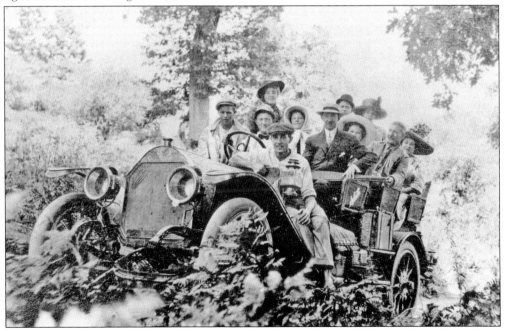

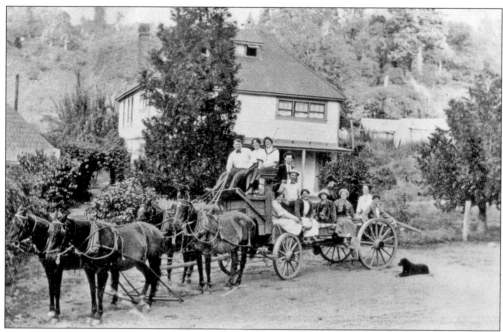

HEY RIDE. Bailey (left) proudly takes up the reins for this horse-drawn outing in 1913. As a dental student and the youngest of the Bailey offspring, Milton delighted in sharing his love for the mountain and his childhood home. By his side is the demure Adalind Shaul, a vacationing schoolteacher from San Diego. That summer, they became engaged and were married after Milton's graduation the following year.

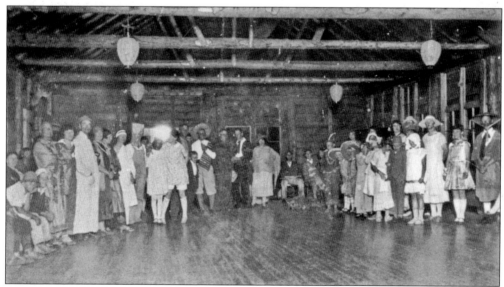

THREE PIECE ORCHESTRA. Using lumber from his steam-driven sawmill enterprise, Doctor Bailey built this dance-hall annex around 1920. When Prohibition became law, a sheriff was required to "preside at all dances" in San Diego County. Milton quickly became a duly appointed deputy, thereby providing the lawmakers with strict compliance, albeit with tongue in cheek.

CIVIC PRIDE. Striving not to be outdone, "the Palomar float" gaily glides down Escondido's Grand Street in the Grape Day Parade *c.* 1915. Milton continued to improve and promote his resort business, founded by his parent's some 25 years earlier.

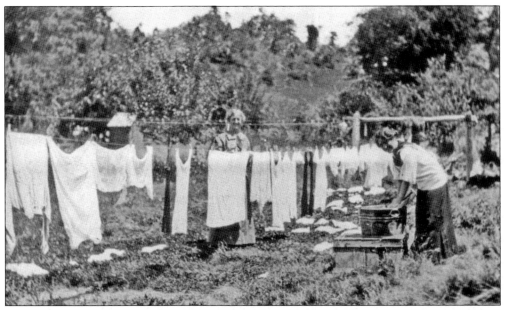

LEARNING A TRADE. "When I married Milton Bailey I didn't realize I was marrying a hotel," said wife Adalind (right in 1915). As the seasonal proprietress of Palomar Resort, she discovered that, unlike her former teaching career, an innkeeper's work is never really done. Assisted by a full staff, the resort was in operation seasonally from Memorial Day through Labor Day during the next three decades.

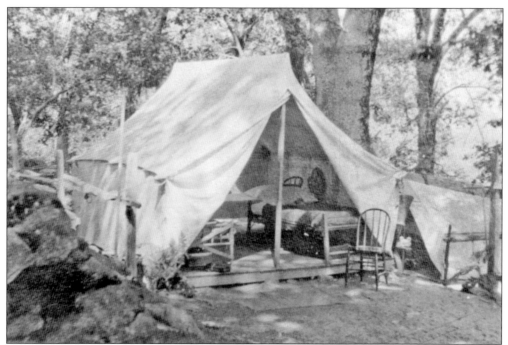

SAFARI SHEIK. Between World War I and World War II, resort clients could rent one of these fully appointed tents at Bailey's for $1 per day. Each included two beds, linens, a night table, a water pitcher, a basin, a dresser, two chairs, and a kerosene lamp. Guests could take meals at the hotel dinning room, or cook out at the campsite. Teddy Roosevelt would have felt right at home.

TENNIS ANYONE? The dirt court was packed solid by a hand-drawn concrete roller as the guests squared off in friendly competition. This promotional photograph from 1924 was intended to illustrate the vigorous, outdoor vacation lifestyle offered high atop the mountain at Palomar Resort.

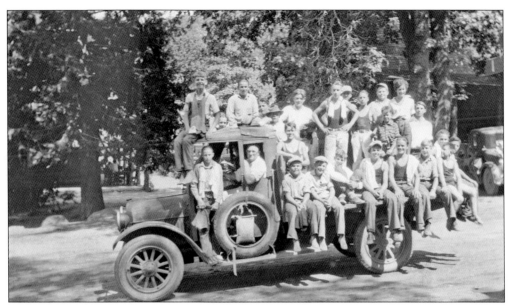

IDEAL FOR BOYS. "Modern parents are beginning to realize that a certain amount of wholesome country life is essential to the normal development of a boy. Palomar Resort is located on a mountain ranch. It is operated by its original owners, and because of its home atmosphere it is especially suitable as a vacation place for boys." So reads a resort flyer from 1920s, appealing to parents concerned with the effects of their fast-paced modern world. Above, Doctor Bailey pauses before a trip to the Iron Springs swimming hole. Below, patrons relax on the hotel porch after lunch. Hayrides, horseback riding, bonfires, and barn dances were a few of the many activities offered at this Edwardian-era getaway.

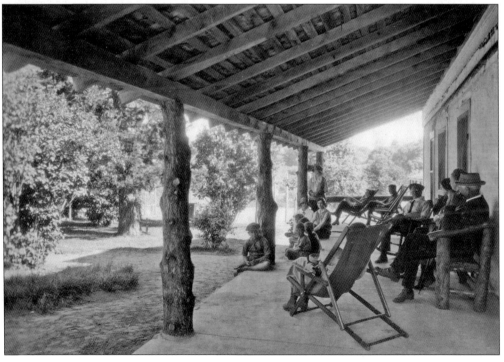

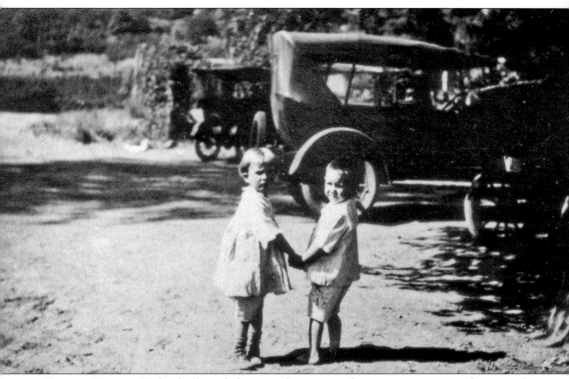

FOREVER YOUNG. With a backward glance at the camera, these youngsters pause for a snapshot in time. As adults, many look back on simple days spent atop the mountain and appreciate how the experience both shaped their view of the world and helped define their place within it.

Nine

THE BIG EYE AND LITTLE GREEN MEN

Many journey to Palomar seeking the heavens. For some, the calling is highly personal and for others purely professional. By the mid-1920s, the mountain was being eyed by men of science as the site for the greatest scientific endeavor of the 20th century. The goal was to extract secrets from the universe using a machine of unprecedented scale and precision. Never had anything so grand been attempted, and man's understanding of the universe would be altered forever.

Palomar Observatory owes its existence to one man of extraordinary vision, George Ellery Hale. In his productive life he personally set in motion the great scientific achievements of the Yerkes 40-inch telescope, the Mount Wilson 60- and 100- inch telescopes, the re-founding of Caltech as a premier research institution, and his crowing achievement, the 200-inch telescope on Palomar Mountain. Immensely significant in the popular imagination, the Palomar project was not to be surpassed in peacetime scale or scope until the Apollo program placed a man on the moon.

The annals of the Palomar Observatory project contain a host of singular personalities without whom the glass giants would never have been realized. Hale, though brilliant, was tormented by imaginary demons. Working in secret, a one-armed master optician named Schmidt would only reveal his technology in exchange for funding a huge machine of his design. There was the cranky, practically deaf architect who inspired major elements of the telescope and dome, then created astonishing mechanical sketches based solely on blueprints. A former day laborer would obsessively grind and figure the 14-ton mirror for nearly a decade. A self-promoting astronomer would literally ride the big instrument to personal glory and in the process expand knowledge of the universe on an incredible scale, later becoming namesake to the Hubble space telescope.

A host of others equally significant are linked to the Palomar project. There is the celestial pulsing orb, discovered by scientists and briefly code-named LGM for "Little Green Men" and the former Palomar cafe worker who became famous for his close encounters with beings from outer space.

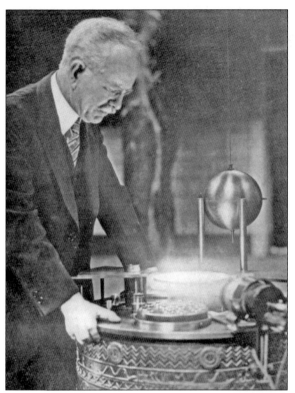

A MOST REMARKABLE MAN. George Ellery Hale (1868–1938) was by any standard a giant of vision and personal energy. Born to wealth, he rejected business to study the heavens. He was plagued by nervous exhaustion and visions of taunting elves in the night, yet he was the galvanizing force behind the world's four largest telescopes, culminating with the massive 200-inch project on Palomar Mountain. (CIT.)

STAYING FOCUSED. Sporting suit and tie for this meticulously sketched occasion, an archetypical astrophysical observer stiffly peers into the tiny eyepiece atop Hale's 200-inch telescope. This was the first instrument large enough to accommodate an onboard observer. The inset at lower right provides scale for the 550-ton machine and its tiny occupant in this 1940 conceptual drawing by architect and telescope-maker Russell Porter. (CIT.)

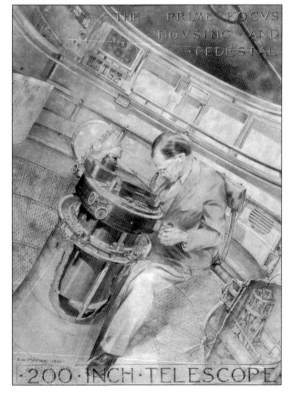

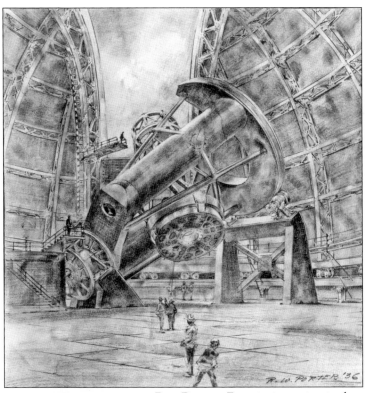

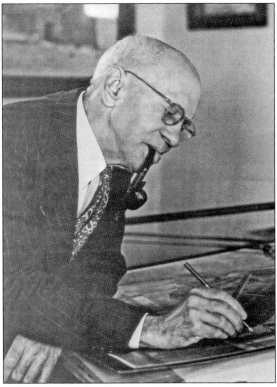

PIPE DREAM. From its inception in the 1920s, the Palomar project was deemed impossible by many respected scientists and engineers. In this hand-drawn 1936 pencil sketch (above), Russel Porter provides an artist's conception to help guide development, which was then in a state of design flux. Here the massive drive gears are shown coverless, and the gigantic horseshoe bearing is supported by huge rollers, later found to be unworkable. The bearing problem was ultimately solved through the invention of friction-free, high-pressure oil plates. At left, Porter (1871–1949) puts the finishing touches on another of his many remarkable pencil drawings. The nearly deaf visionary-architect created drawings of complex telescope mechanisms from the original blueprints. All are extremely precise and offer minute details, which are referenced by Palomar Observatory technicians today. (Both, CIT.)

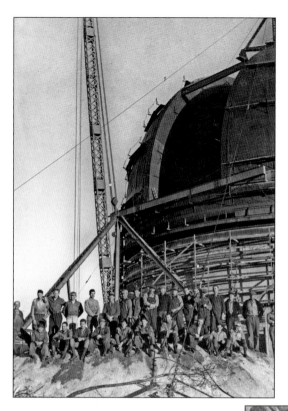

PRIDE OF WORKMANSHIP. Taking a short break from construction duties, these steel workers pose for a group photograph in the early 1930s. The rotating observatory dome weighs in at 1,000 tons and was the largest electrically welded structure in the world at the time. Due to the remoteness of the mountaintop, the crew was housed in camp-style dormitories and labored on the project in all weather, year-round. (CIT.)

ASTRONOMICAL COMPUTER. Decades before the advent of digital computers, this astronomical calculator was a gear-driven marvel. Here a typically well-attired viewer is sketched above an x-ray style cutaway in this 1940 Porter original. Fourteen-foot diameter bull gears are driven through this complex mechanism by a tiny electric motor. The computer was designed to automatically point the 1,100,000-pound machine to an accuracy of about one-thousandth of a degree. (CIT.)

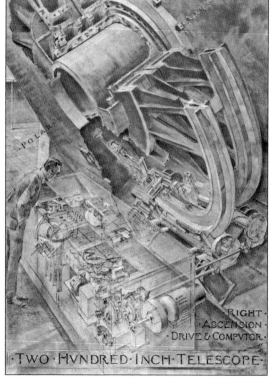

BANDWAGON. In this 1938 letter, an elected county official queries the head of observatory construction on Palomar in an effort to set the record straight as only a consummate politician knows how. The official seeks confirmation that indeed his time in office coincides with the crystal-clear viewing conditions atop the mountain during the 1920s.

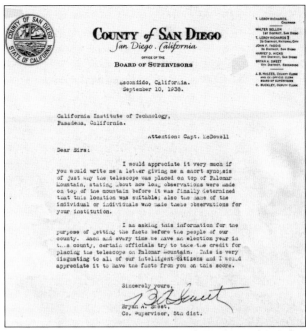

THE HUGE TELESCOPE. The mighty Hale takes an initial bow following assembly around 1938, while the 17-foot diameter, 14-ton glass mirror continues to be ground at faraway Caltech. In its place, a concrete disk of equal weight and shape allows the precision machine to go through testing maneuvers. Another nine years will be required before the Big Eye is transported to the mountain. (CIT.)

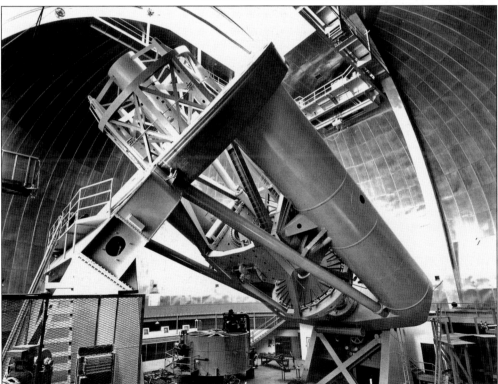

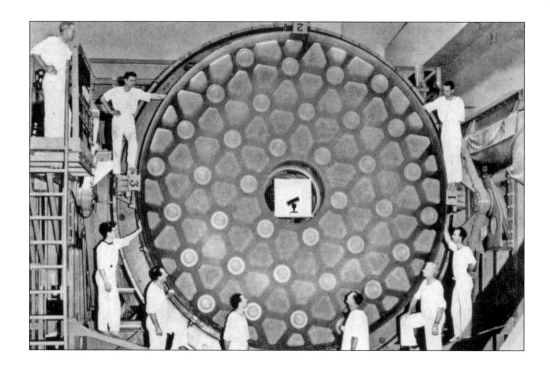

THE GREAT WORK. Taking years to create, the 200-inch Pyrex disk was poured at Corning in New York and transported cross-country to Caltech's optics laboratory in Pasadena, California. It would spend eight years there before shipment to Palomar. The disk would be under the strict and attentive control of Marcus Brown (above, center right in 1936). Hale recognized the rare qualities of a lens-maker in the intense young man and former day laborer and promoted Brown over more senior personnel. Brown obsessed to the extreme over the disk, which required the grinding of a 6-inch depression to form its final concave shape. Allowing few to see his work and fewer to actually touch the glass, upon relinquishing his masterpiece, he signed his name on the inside edge of the mirror with a diamond stylus (below). (Both, CIT.)

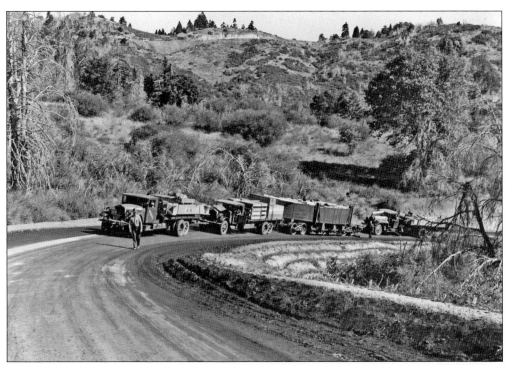

THE BIG EYE COMETH. Major sections of the 550-ton telescope and its mounting were transported up the mountain via the Highway to the Stars. By 1938, the telescope was all but completed, lacking only the giant mirror. Nine years later, without public announcement, the long-awaited eye took its final journey from Pasadena to its new home on Palomar, captured here by *Life* magazine in December 1947. (CIT.)

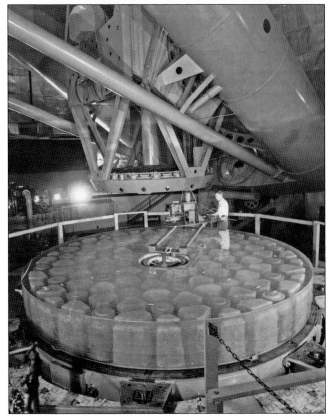

FINISHING TOUCHES. Final figuring would continue in the dome for another year. Lacking its finished molecule-thick aluminum coating, the mirror was tested by night and polished by day for months. The final effort was made with the optician's bare thumb, as he wiped small areas, removing glass a few millionths of an inch thick per stroke. (CIT.)

WHEN THE BIG EYE OPENS

200-INCH Palomar Mountain telescope is near completion.

At last we may know the shape and future of our universe

Palomar Mountain Observatory, as befits one of the great engineering feats of mankind, will soon be peering into outer space for more knowledge about the universe of which man's world is an infinitesimal part.

Some astronomers believe that California Institute of Technology's 200-inch telescope, now nearing completion, will reveal whether or not the canals on Mars could have been designed by intelligent beings. But such a revelation would be only incidental; the new instrument was designed to penetrate far, far beyond Mars, and perhaps far beyond the most distant stars men have ever seen. It was designed not to magnify the stars, but to make them brighter.

May Tell Whether Sun Will Explode

The giant of Palomar stands a chance of determining, once and for all, whether the universe, as it thus far appears to be doing, is expanding. It should provide evidence for or against the theory that the end of the world conceivably may result from the explosion of the sun. And it may supply enough data upon which the astronomers, or other cosmologists, can compute whether the universe is finite or whether it simply goes on outward forever.

The 200-inch giant will concentrate four times the light that the 100-inch Mount Wilson telescope is capable of picking up. Translated further by means of elementary solid geometry, this means that the astronomers will have eight times as large a universe to make discoveries

13

THE GREATEST ACHIEVEMENT. Never before had the public awaited such an awesome event as the final unveiling of the Palomar' Observatory's 200-inch telescope. Conceived in the 1920s, engineered and constructed during the 1930s, and judged optically sound by 1948, the glass giant of Palomar was now the stuff of popular legend. The builders overcame a nearly impossible engineering challenge, a disastrous mirror pore, followed by a hundred-year flood at Corning Glass, and the Second World War. National magazines such as *Science Illustrated* (left, June 1947) and *Collier's* (below, May 1949) heralded the coming age of celestial enlightenment. (Both, CIT.)

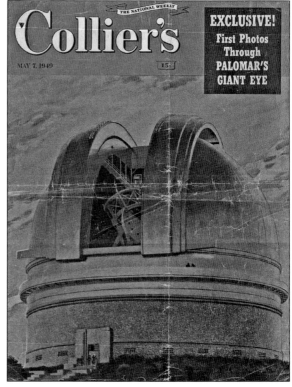

THE NATIONAL WEEKLY

Collier's

MAY 7, 1949 15¢

EXCLUSIVE! First Photos Through PALOMAR'S GIANT EYE

THE CRAB NEBULA. Recorded by the ancients over 3,000 years ago this photograph, taken by the 200-inch Hale telescope, shows the remains of a supernova bright enough to light the daytime sky. Within the gaseous interior is a rapidly rotating neutron star only a few miles in diameter. Pulsing energy at about 1/30th of a second, it was briefly considered a message sent by extraterrestrials. (CIT.)

DEDICATED SERVANT. As an invited attendee to the 1948 media event and telescope dedication, Palomar postmistress Adalind Bailey, pointing to the famous commemorative stamp, poses with actress Greer Garson. The ceremony was attended by hundreds of notables from the scientific and business communities. Having made Palomar her life for 35 years, she ascended the prime focus elevator with superintendent Byron Hill on that red-letter day, rising majestically over an admiring crowd.

THEY HAVE LANDED.
George Adamski (left) is considered to be a founding father of "ufology," or the study of unidentified flying objects. Traditionally called flying saucers, Adamski first photographed the craft below in May 1947. By March 1953, he reported the landing of a Venusian scout ship at his daughter's modest campground and cafe known as Palomar Gardens. Perhaps the best known of all early photographers on the subject, Adamski's subsequent contacts resulted in a lively following and further encounters. Located on the now-famous Highway to the Stars, tourists traveling to view the grand Palomar Observatory would often take refreshment at Adamski's establishment. There he lectured on flying saucers and contact with advanced beings from other worlds. (GAF.)

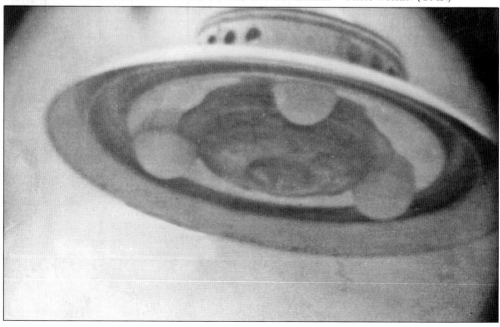

ILLEGAL ALIENS. Adamski's first book *Flying Saucers Have Landed* (1953) is lauded as a groundbreaking work documenting the presence of highly technological beings that frequently visit the earth. Officials of the FBI and U.S. Air Force debriefed Professor Adamski (as he was then known) at his Palomar Gardens cafe regarding his observations. Below, a diagram of the scout ship complete with alien designators as presented to Adamski by his "friends from out of town." His experiences predated the Soviet Sputnik satellite and the international space race by a decade. In 1962, he announced he was scheduled to attend a conference on Saturn, which was found to be incredible by many of his then-supporters. (Both, GAF.)

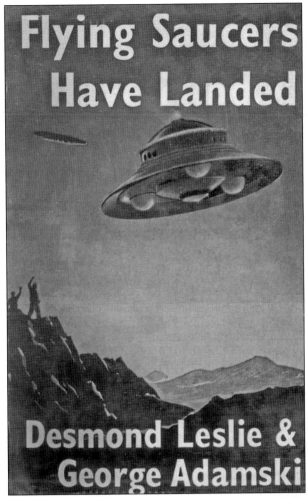

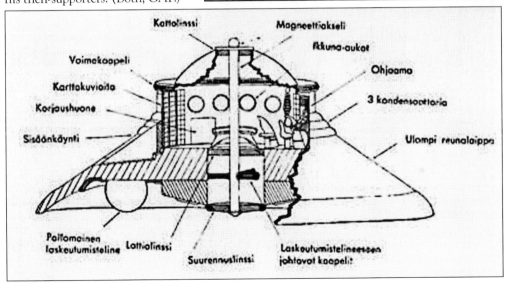

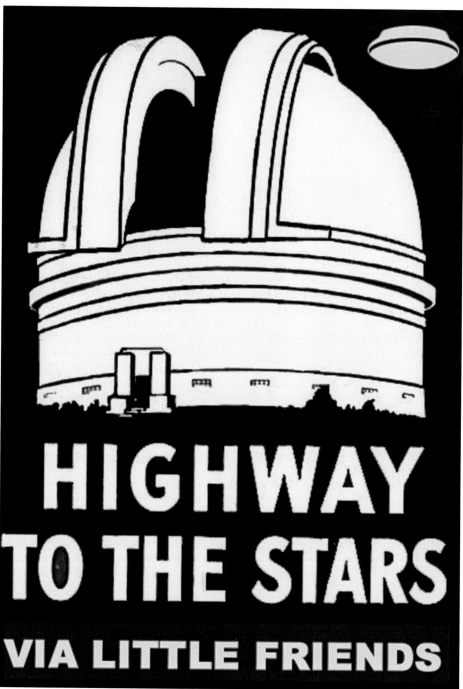

HIGHWAY TO THE STARS

VIA LITTLE FRIENDS

A HIGHER CALLING. In ironic mixed metaphor, traditional reverence for the famous Palomar Observatory is combined here with the equally infamous Palomar Gardens to create a lighthearted symbol of man's universal quest for knowledge beyond the bounds of mother earth. Through it all, Palomar Mountain serves as a backdrop behind a star-covered stage of both celestial musings and disciplined astrophysics. In both cases, a vivid creation is painted from a palette rich in forested enchantment and heavenly inspiration.

EPILOGUE

With respect to the modern juggernaut that has been Southern California development over the last century, Palomar Mountain has changed little. To the south, a sister mountaintop community, founded about the same time, boasts a crowded theme park–style downtown district, catering to the impulse purchases of drive-through weekend visitors, perhaps seeking comic relief in the modern, sanitized gloss that now covers what was once a truly vibrant and colorful mining town.

To the contrary, Palomar Mountain has been blessed, as it was left untouched by the mining industry and through-roads. The mountain benefits from traditionally strong institutional presence of publicly managed wildlands and the dark-sky requirements of Palomar Observatory. Seen as an obstacle to shameless enterprise and promotional development, this unique quality has kept the mountain pristine into the 21st century.

Palomar has had a profound effect on many lives. With a population of but a few hundred and without a strip mall or gas station, the steep and undulating south grade, still known to a few as Highway to the Stars, remains the road less traveled. That such a community not only survived, but prospered, is a testament to the sense of ownership felt by those who recognize the stellar qualities of the mountain. Here community volunteerism is strong, as is the social responsibility that with it goes hand-in-hand.

Armed with the realization that there is much to lose and little to gain, the growth inherent to much of the modern world is unappealing in the rarified mountain air. The zero-sum equation of healthy subsistence is overwhelmingly supported by thousands who have felt the Palomar connection and from afar continue to make the mountain a priority in their lives. All the old-timers are gone now by at least two generations, yet their spirits survive and continue to shape Palomar's future, in part from the long, misty trail of the mountain's past.

AT THE CROSS ROADS. What began as Thompson's Summit Grove (above in 1956) has evolved into The Store, offering an enticing and eclectic array of merchandise, and Mother's Kitchen, serving up vegetarian cuisine extraordinaire (below). Both are literally and figuratively at the center of the Palomar Mountain community and are owned and operated by the Spiritual World Society, Palomar Mountain. Once known as Nellie, California, the communal post office here has proudly borne the mountain's place name for nearly a century. A story from long ago tells of a letter simply addressed "Sally California" finding its way to the mountain, as Nellie was the one feminine-named post office in the state. (Below, MTB.)

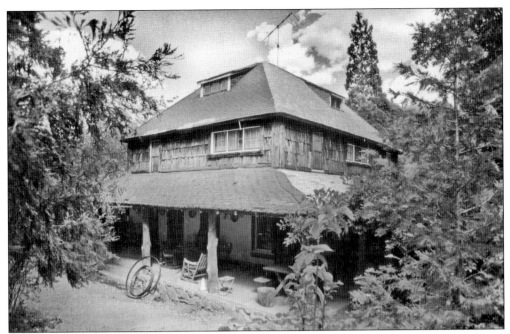

FROM THE ASHES. Approaching a century old, the venerable Bailey House, centerpiece of Palomar Resort, shows its age in this 1970s photograph. Built in 1888, and once the premier resort destination on the mountain, the former hotel in 1939 became the residence of widowed Adalind Bailey. Her place evolved into an active social center for the community, where everyone was welcomed to congregate. Tragically, the old adobe homestead-come-hotel burned to the ground in 1997. Unwilling to accept the loss of this legacy, the family reconstructed the multi-story building in the same design and original footprint (below). Fully restored with period look and feel, Bailey's once again offers patrons a unique and historical destination-resort experience. (Below, DPA.)

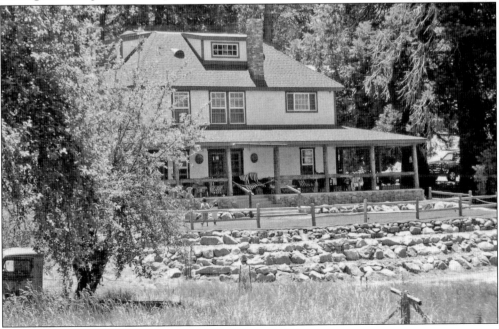

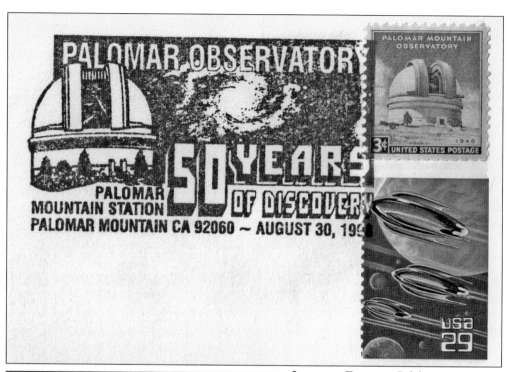

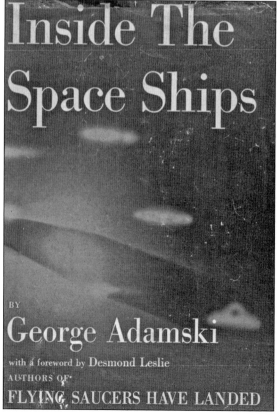

Inside The Space Ships

BY George Adamski

with a foreword by Desmond Leslie

AUTHORS OF FLYING SAUCERS HAVE LANDED

INTO THE FUTURE. Celebrating the five decades of discovery at Palomar Observatory, an elaborate cancellation stamp memorializes the occasion in 1998 (above). The original 3¢ Palomar stamp contrasts with a more recent addition, sporting the distinctly futurist look familiar to mid-century America. Upon the success of his first book, *Flying Saucers Have Landed*, George Adamski's fame grew and included lectures at his Palomar Gardens spaceport, a world tour, and an audience in 1959 with Queen Juliana of the Netherlands. In his second work (left), Adamski again travels with his "friends from out of town." Today the Adamski legacy carries on through the George Adamski Foundation. (Left, GAF.)

CELESTIAL PORTAL. Even then a tourist draw, the massive 200-inch dome (right) nears completion in the mid-1930s. Originally built for glass-plate photographs, Hale's telescopes had revealed celestial gas clouds within our Milky Way galaxy to be actually far-off island universes. Employing the new 200-inch telescope, astronomer Edwin Hubble's work expanded the known size of the universe almost beyond measure. Thought to be only a hundred-thousand light-years across, newly discovered galaxies were actually billions of light-years in size and traveling at unimaginable speeds. Today electronic enhancement has rendered glass-plate photography obsolete, increasing the light gathering power of the 200-inch to rival that of the Hubble space telescope. Palomar Observatory is open to the public during daylight hours and includes a learning center, museum, and visitor's gallery under the awesome 550-ton Hale telescope (below). (CIT.)

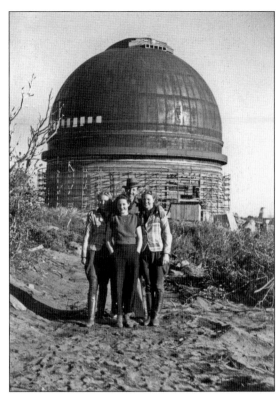

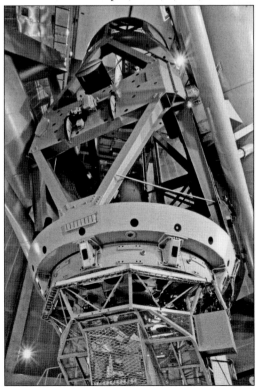

AT THREE DEAD-END ROADS. Palomar's colorful past is present and accounted for, tucked within the mountain's quiet enclaves. Built from saw-milled siding around 1890, Bailey's store and post office (above) was still in operation by the late 1940s. Flanked by Detroit's latest models, the quaint building was even then considered a rustic holdover from the mountain's pioneer past. Slow to change and long retired from postal service, the old store retains a certain charm in this 1970s photograph (below). The building—which was saved from a devastating fire in 1997—retains its pioneer roots today, serving as on-site museum, photograph subject, and event venue for the family's century-old resort.

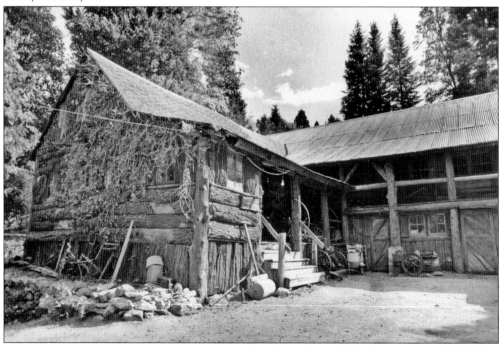

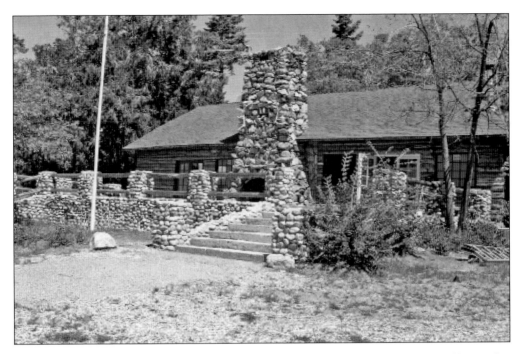

SAME YET DIFFERENT. Originally constructed as a community center for the Birch Hill area, this remarkable building has evolved in name and operation over the decades. Once called the National Forest Country Clubhouse, Edgewood Tavern, and Skyline Lodge, it is now mostly known as "the Lodge" (above). Below, colorful George Adamski's Palomar Gardens Cafe and saucer-depot still retains its former charm. Operating today as Oak Knoll Campground, the full-service facility boasts a swimming pool, recreation area, star gazing, and a George Adamski memorial learning center. (Above, MTB; below, GAF.)

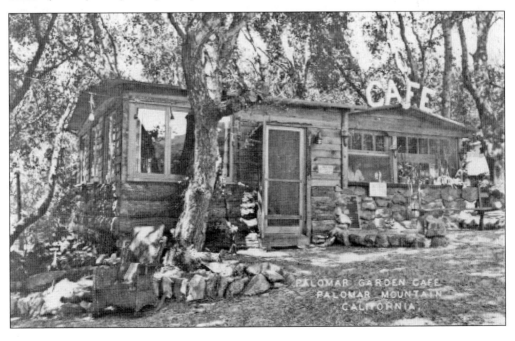

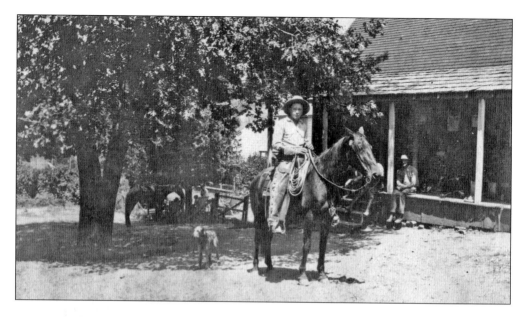

OF MAN, DOG, AND RANCH. Sporting the tools of the trade, this mounted cowboy, with his dog and lariat at the ready, drops in at Bailey's for weekly mail call around 1900 (above). Today fifth-generation Palomar Mountain rancher Dutchy Bergman (below) maintains much the same equipment over a century later. Mail call is now a daily routine, and stock trailers, two-way radio, telephone, and electric power add a few modern conveniences to the age-worn livestock business. Cell phone coverage is nonexistent here in the family's 1,000-acre French valley pasture. (CHB.)

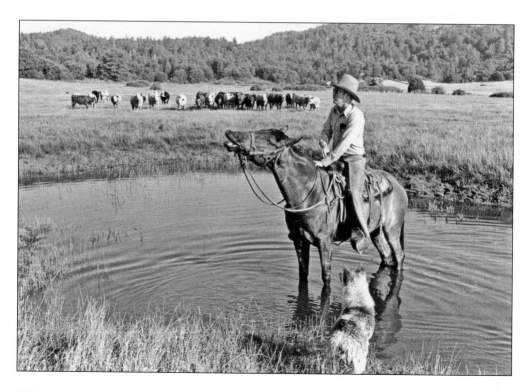

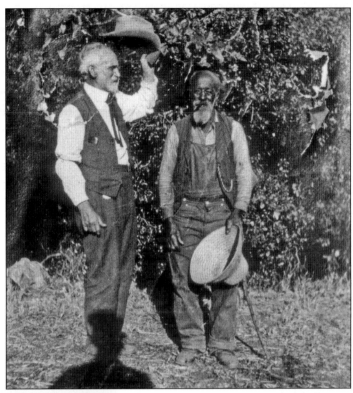

OLD FRIENDS. Theodore Bailey doffs his cap to longtime neighbor, friend, and fellow mountain pioneer Nate Harrison in this rare 1920 photograph, taken shortly before Nate's death. Turning over the mountain enterprise to his son, Bailey left Palomar soon after and, like Nate, lived for just a short while "down below." Perhaps these hearty old-timers appreciated the transitional moment. The new age of automobiles and flying machines, of telephone and electricity, of moving pictures and fast-paced living seemed to beckon everyone into a glorious future just as the horse-drawn world of open spaces and social community, with its simple rewards, was drawing to a close. At left, youngsters pose at Nate's monument sometime around 1930. Erected by friends and neighbors of the former slave, the stone monolith became yet another curiosity to passersby.

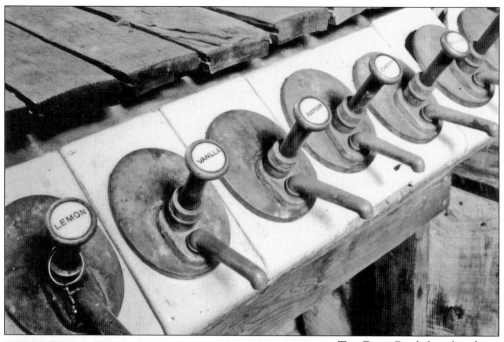

THE PAST. Brightly colored candy syrups once enlivened ice cream sundaes at Baileys. Long unused, these tarnished dispensers remain at the ready for youthful customers who'll never return. Now providing content for an artist's eye, the past quietly lingers atop the mountain. (Courtesy Jan Thompson.)

THE PRESENT. This hand-split cedar fence is evidence of a formally active Mendenhall Cattle Company loading corral. Once a necessary part of this agrarian enterprise, after a century and half it now seems resigned to await eternity. As ranch livestock graze nearby, decades of exposure have left these posts gray with age and covered in the mossy, soft-green patina of forsaken infrastructure.

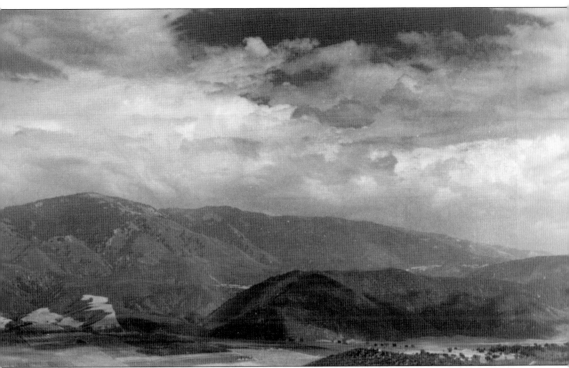

THE FUTURE. Looking northeast from the blue Pacific, the long humpback of granite that is Palomar Mountain sleeps off another summer afternoon. Yet, as framed by the camera lens, she invokes the story of the remarkable little community within and offers a past worth the telling and a future worthy of the effort. (USFS.)

www.arcadiapublishing.com

Discover books about the town where you grew up, the cities where your friends and families live, the town where your parents met, or even that retirement spot you've been dreaming about. Our Web site provides history lovers with exclusive deals, advanced notification about new titles, e-mail alerts of author events, and much more.

MADE IN THE USA

Arcadia Publishing, the leading local history publisher in the United States, is committed to making history accessible and meaningful through publishing books that celebrate and preserve the heritage of America's people and places. Consistent with our mission to preserve history on a local level, this book was printed in South Carolina on American-made paper and manufactured entirely in the United States.

This book carries the accredited Forest Stewardship Council (FSC) label and is printed on 100 percent FSC-certified paper. Products carrying the FSC label are independently certified to assure consumers that they come from forests that are managed to meet the social, economic, and ecological needs of present and future generations.

FSC
Mixed Sources
Product group from well-managed forests and other controlled sources

Cert no. SW-COC-001530
www.fsc.org
© 1996 Forest Stewardship Council

Find Your Place in History.